FUNDAMENTALS
OF
OIL PAINTING

A revised and enlarged edition of The Technique of Oil Painting

FUNDAMENTALS
OF
OIL PAINTING

BY LEONARD RICHMOND

WATSON-GUPTILL PUBLICATIONS · NEW YORK
PITMAN PUBLISHING · LONDON

Paperback Edition
First Printing, 1977
Second Printing, 1977

First published 1970 in the United States by Watson-Guptill Publications,
a division of Billboard Publications, Inc.,
1515 Broadway, New York, N.Y. 10036

Published in Great Britain by Pitman Publishing, Ltd.,
39 Parker Street, London WC2B 5PB, whose *The Technique of Oil
Painting,* © Executors of the late Leonard Richmond, 1965, furnished
the basic text for this volume.
ISBN 0-273-01154-5

Library of Congress Catalog Card Number: 74-98152
ISBN 0-8230-2026-6 pbk.

Manufactured in U.S.A.

CONTENTS

LIST OF COLOR PLATES

INTRODUCTION

There are many people who take up oil painting either professionally or as a hobby, but it is given only to the few to understand its full possibilities as a medium for expressing pictorial matter. In fact, oil painting can be a snare to the uninitiated. Its comparative ease lulls the beginner into a false sense of security, since mistakes can be so easily remedied, either by scraping the color off with a knife, or by rubbing it off with a rag. Herein lies the danger of this apparently facile medium. It does not require much skill to make a plausible looking oil painting without stylistic handling of the pigment, but there is a vast difference between the inexperienced beginner's lack of method in covering a canvas, or similar surface, and the experienced painter's style and knowledge of this fascinating but elusive material. No artist can learn too much of the triumphs of past techniques, the success of present-day technique, and the possibilities of good results arising from his or her own experiments. The greater the knowledge, the greater the chances are that some individual technique will be achieved.

The essential value of this book lies in the fact that the old and modern techniques are laid bare to the eye by color reproductions, many of which are the same size as the originals. Thus, every brushmark truly explains its function, every subtle tone becomes visible, and all manner of textures are easily observed (and consequently, easily understood) by the reader.

It might also be mentioned that, in this book, the author holds no brief for any special type of art, modern, academic, or primitive. Oil painting technique is strictly adhered to, from the first chapter to the last.

L. R.

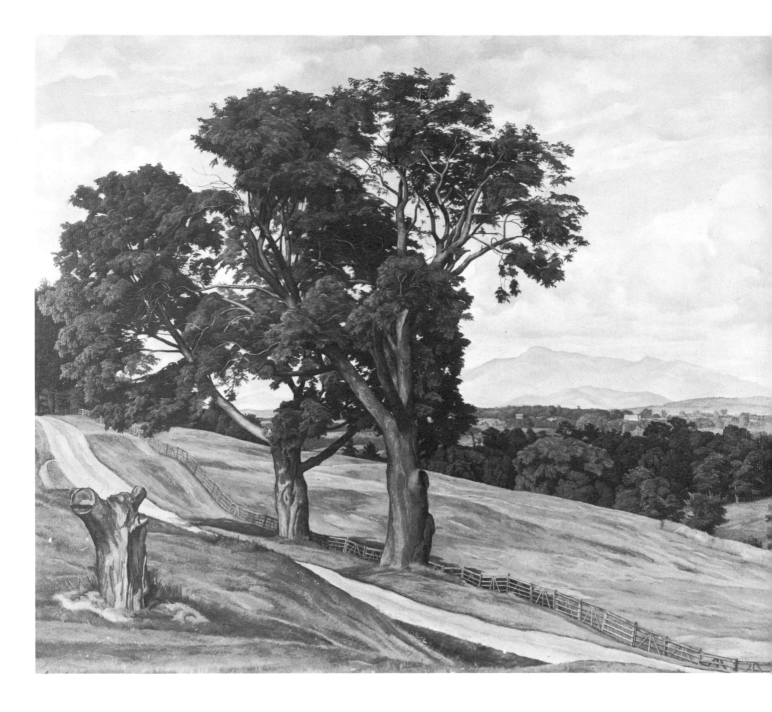

Trees and Mountains by Luigi Lucioni.

The apparent precision of this rendering is deceptive, for the viewer may be inclined to feel that this landscape contains more detail than is actually there. The artist has created the *illusion* that he has painted every leaf in the tree. However, in reality, he has begun by observing the tree and noting that it divides into clusters of light and dark, where some groups of leaves are in shadow and others are caught by the sunlight. The dark patches are precise in silhouette, but contain relatively little detail; the artist has concentrated his detail in the lighter areas.

This selective use of detail is a very effective way of suggesting more "finish" than is actually in the painting. In the same way, he has focused on certain areas of the foreground to indicate precise blades of grass, interpreting the rest of the painting as patches of color and form; but the viewer is inclined to feel that he can "see" blades of grass throughout the entire landscape. In short, when the painter uses precision selectively, the viewer's imagination is stimulated to believe that this richness of detail pervades. (Photograph courtesy *American Artist*.)

1

MATERIALS

When selecting art materials, it is advisable to get the best. In this way, students will have no unnecessary difficulties in trying to express a good technique. The materials required are wide and varied. The first thing one naturally thinks of in oil painting is the canvas.

CANVAS It is advisable for a student to begin oil painting on a fairly coarse canvas, since the rough grain assists in giving a certain quality, or vibration, in the handling of the oil pigment. A smooth grained canvas is difficult for a beginner, as the oil pigment is likely to slide or glide too easily over the surface, thus causing a shiny and most undistinguished lack of texture. It is well to realize that the texture of oil pigment should never be lost sight of. Linen canvas should be woven of pure flax fiber, and unbleached, or only slightly bleached. It can be purchased from any art supply store.

SIZING THE CANVAS It is best, if possible, to prime one's own canvas, so that it can be done in accordance with the style of technique peculiar to the artist. The best sizing for linen canvas (before priming) is gelatin or hide glue, although casein is sometimes used. Casein is an extract of cheese, and can be obtained in a dry state from chemical suppliers. Cold water causes it to swell, but it needs a few drops of ammonia to dissolve it. The proportion of casein to cold water varies occasionally, since most samples of casein show considerable differences in strength. Sometimes the proportion of one ounce of casein to five ounces of water answers the purpose, and other times the same amount of casein may require eight ounces of water. The mixture of casein and cold water needs stirring well for quite a time, with a bone or wooden spoon; and afterwards (during stirring) the addition of ammonia in drops, until the casein is dissolved, thus forming a size ready for use. Although quite permanent and entirely free from the attacks of moisture, casein has a drawback in its brittleness, so that it is advisable to lay on the size thinly. Some painters use glycerin as an additional ingredient, thus obviating the brittleness of casein, but unfortunately it destroys the latter's damp-proof qualities.

It would be fatal to use oil pigment directly on an unsized canvas. Oil, coming directly into touch with the fibers of the canvas, burns the material and even-

tually destroys it. It is absolutely necessary to use a coat of such a nature that it will protect the canvas from the evil effects of outside influences, for which, of course, gelatin, hide glue, or casein size answers the purpose.

If the canvas is closely woven, a single coating of size will do. If the size used is quite pure, it will then be noninjurious to colors, imperishable, and free from damp. Also, its elasticity prevents it from cracking. Personally, I can recommend gelatin as the best size for the purpose. It is inexpensive and pure; and it is also very quickly prepared by being dissolved in hot water.

PRIMING THE CANVAS

After the canvas has been well sized with gelatin, a single layer of white lead can be lightly painted over the dry size to make a priming.

For a canvas that is rather coarse, a second layer of white lead will be necessary, but great care must be exercised; for, if the first coat is not thoroughly dry, the oil in the first layer, having no means of escape, will become acid, and later burn the canvas through the coating of size. The canvas will be more or less absorbent according to the thickness of the priming. The paint will be matt in appearance if the priming is thin, and less matt in proportion to the thicker priming.

If, however, students prefer to purchase canvas already primed, direct from the art supply store, it is just as well to scratch the priming with the fingernail; if the priming comes off, it will prove that the priming is not yet dry. In any case, no canvas which has already been primed should be used until some six or eight months after the priming has been done, so that any oil in it will come to the surface. The color of the priming will then have reached its normal condition, which is slightly gray in tint.

Formalin, sprayed on the back of the canvas, has lately been used by artists as a preservative against damp. A good sprinkling of this liquid behind the canvas protects it from any attacks of moisture, and from any unpleasant conditions caused by foul air.

HARDBOARD

This material (sometimes known as Masonite) has become so popular with painters in oil colors that it can be obtained from art supply shops in stock sizes and ready primed; alternatively, it can be obtained in large sheets from any building supplier and sawed to size. Hardboard is smooth on one side and coarse grained on the other. Either side may be used, but some painters prefer the smooth side because it enables them to build up their own surface texture.

BUCKRAM

This is very useful for sketching (see Chapter Six). It is very porous and needs two or three coats of size on front and back. Its dark brown color provides a useful basic tint on which to suggest highlights, and it is valuable for obtaining quick sketches of transitory effects. Since its durability is doubtful, it should not be used for serious work.

BRUSHES The brush chiefly used for oil painting is the *bristle brush*. To acquire the feeling of oil painting, it is probably the best plan for the student to get bristle brushes that are square in shape, so that when decisive touches of the brush are made on the canvas, there will be left a clear-cut edging of the pigment, as seen in the lower example in Plate I.

Another brush which is useful is known as the *filbert*, which has the same qualities as the square brush, but does not leave such a decided edge. It is a compromise between the square and the round brush. Between twenty and thirty brushes are necessary as a preliminary equipment to painting, from very small brushes up to brushes 1½″ wide.

Occasionally, sable brushes can be used for delicate detail, but caution is necessary as regards the use of sable (or exceedingly small brushes) in the first stages of painting; in fact, students are well advised to keep away from very small brushes for at least a year, so that the handling may be broad and convincing. There is little difficulty in portraying finicky detail, but it is not so easy to master the broader method.

Oil brushes must be kept perfectly clean. The most economical way (so as to save paint rags) is to squeeze the oil pigment out of the brushes on a piece of newspaper, then dip them in kerosene. Afterwards, dry them with a clean rag. Finally, rub the brushes into a bar of ordinary kitchen soap, and then stir them well in warm water. Repeat the process until they leave no trace or smell of kerosene.

PALETTE These days, the majority of artists use large palettes. It is astonishing how the old masters used to paint such fine pictures with the small palettes which were in use in their time. The advantage of a large palette is obvious: there is more room to mix colors and try experiments with various blends; there is also a freedom from the irritating feeling caused by working in a restricted space. As regards the lay-out of oil colors on the palette, it invariably saves confusion (especially when one is painting rapidly) to spread the colors out in gradated tints from light to dark. Flake white heads the list, lemon yellow or light chrome is next, and so on right down the scale of colors—finishing with ivory black.

In the initial lay-out, certain essential colors should be repeated on the palette. Squeeze out at least four large, separate amounts of flake white from a 1 lb. tube, three portions of yellow ochre, three of alizarin crimson, four of ultramarine blue, and proportional quantities of any other colors that may be deemed necessary. The system of color repetition not only saves a lot of time, but makes it much easier to obtain pure color blends during the painting of a picture.

Always keep the palette clean. At the end of an hour's steady painting, or even less, the student will find the necessity of scraping off impure color pigments (do not throw them away) and wiping a portion of the palette with a rag. After a day's painting, the palette should be absolutely free of any oil pigment and ready again for future use.

The palette should be well balanced, and light in weight. In my own case, when working indoors in the studio, I have the largest one possible, which rests

on an ordinary, cheap, folding card table, placed on the left side of the easel. On the other side of the easel, the brushes and various mediums are placed on a similar table. It is very comfortable to work with the palette in such a position, so that when one is standing it can be seen well below the eye-level, where, resting on the table, it causes no physical difficulty.

The circular palette is generally used for indoor painting, and the square or rectangular shape for outdoors. The latter palette fits more comfortably into the average oil sketching box.

PALETTE KNIFE

A long, flexible knife is essential for mixing colors rapidly, and for cleaning the colors from the palette at the end of a day's work. Some two or three other palette knives should be included in the list, so that painting with a palette knife can sometimes be indulged in. The palette knife for direct painting on canvas should have a fairly good point, and yet be flexible enough to use for squeezing the color into any required direction. Most art supply stores have a good selection of palette knives which are used solely for the purpose of picture-making.

MEDIUMS

Pure distilled turpentine is the most popular medium for mixing with oil colors. It can be used with confidence, as it eventually evaporates and has little effect on the permanency of oil pigment. Linseed oil should be used sparingly with oil colors. It helps to give a glossy surface, but later yellows the various colors. It is advisable to add a generous quantity of pure turpentine so that the artist can paint with fluency. The best mixture is $7/8$ pure distilled turpentine to $1/8$ linseed oil. Many painters prefer copal medium to any other media, but it is important that if this medium is used it should be obtained from a reputable maker, as it can be badly manufactured.

The medium is poured into a metal cup which clips onto the palette. The brush is dipped into the cup to charge it with the liquid. The charged brush is then worked into the required pigments on the palette.

The Barn Chair by Alexander Brook.

One can often "construct" a fascinating still life out of a number of unlikely materials. The artist has placed a conventional vase of flowers in an unconventional setting, built out of an old chair, the walls of a barn, and a coil of rope. The vase of flowers is framed by the chair which is framed, in turn, by the rope which leads the viewer's eye through the picture very much like the marks on a road-map. The entire still life arrangement is framed, finally, by the geometric lines of the wall and floor of the barn. It is interesting to notice that none of the supposedly straight lines is precisely vertical or horizontal, but always slightly askew, and broken by touches of light or dark. Place your finger over the folded bit of paper at the foot of the chair and discover for yourself how important this detail is to the success of the pictorial design. (Photograph courtesy *American Artist*.)

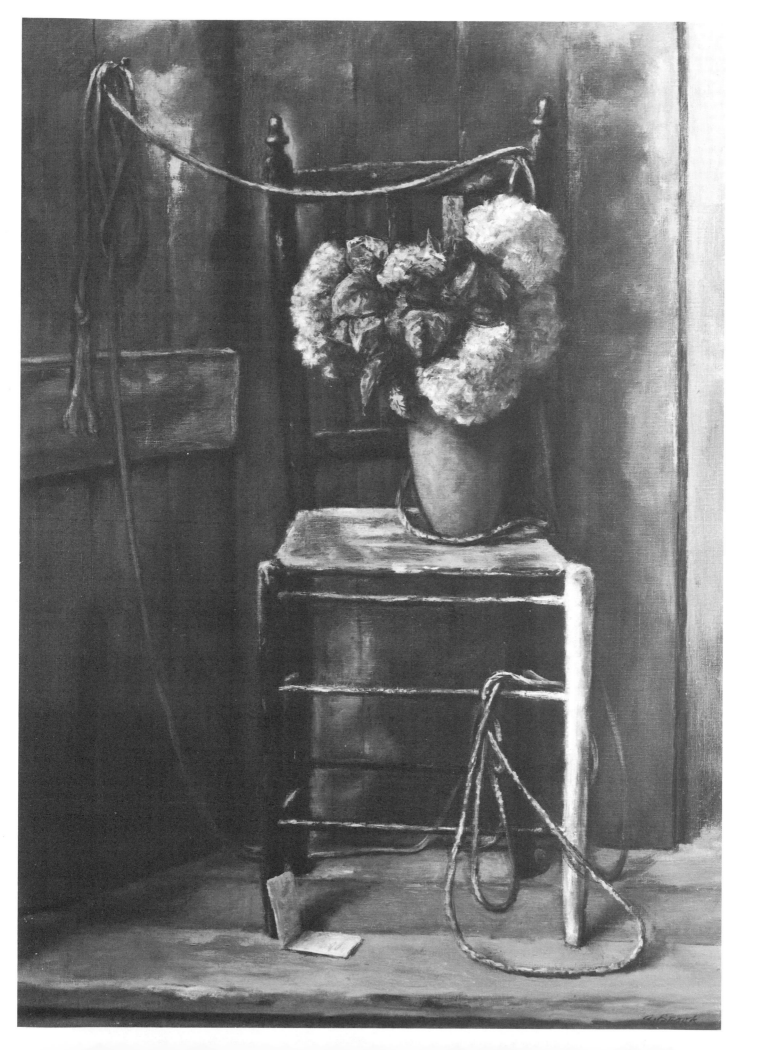

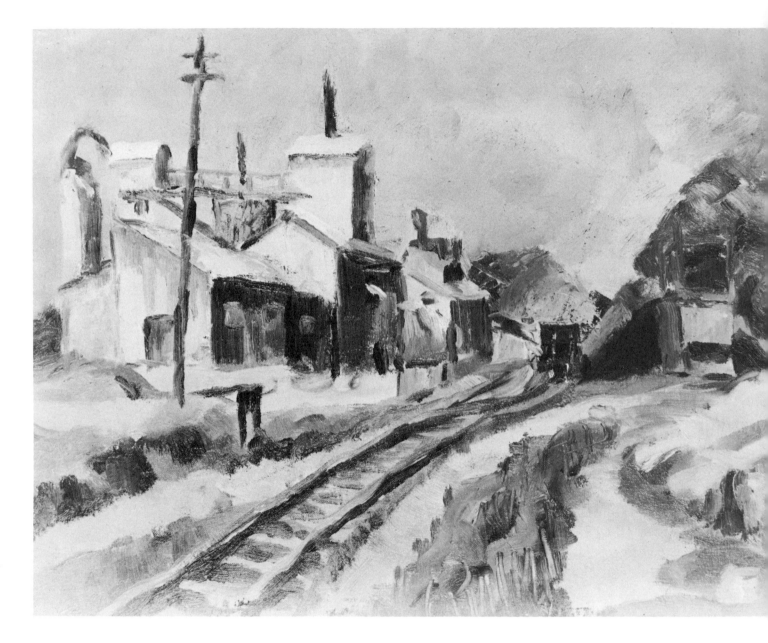

Lime Kiln by Francis Barone.

The vitality of this painting stems from the boldness of the artist's attack. Using large bristle brushes, he has placed the absolute minimum number of strokes precisely where he wants them, never going back to iron the strokes out, blend them, and destroy their spontaneity. The viewer can literally see the artist's hand at work in every stroke, which retains the marks of the bristles and the thick texture of the paint, just as it was applied. Detail has been radically reduced so that the picture is simply an arrangement of rough patches of light, halftone, and dark. The entire effect is that of a sketch, done on location at white heat, although such paintings are often the result of much more prolonged labor than one might think. (Courtesy Pepsi-Cola Company.)

2

HANDLING
THE MEDIUM

In Plate I there are two demonstrations painted on canvas. The one at the top represents an inefficient and poor style of handling oil pigment—its indecision is apparent to the casual observer, and it shows no definite function in expressing form or style. The lower example was done with the same brush, and with the same color, but here the brush was allowed to function in a natural manner—that is to say, the brush was flexed, and pressed strongly on the surface of the canvas, achieving a most definite and decisive delineation of form.

DEVELOP A FIRM BRUSHSTROKE

The student would be well advised to practice this simple manner of using an ordinary oil paintbrush. In this instance, a bristle paintbrush about ¼″ wide was used. Another characteristic charm in the lower example lies in its sparkle, caused in places by the spotty effect of broken paint surfaces, and also by the assertive ridges of paint as seen on the edges of the brushmarks. The spotty color effect is made through the lighter pressure of the brush as it is about to rise from the surface of the canvas. A similar spotty result can be achieved by using very little pigment in the brush and pressing it firmly along the canvas. The ridges so noticeable in the lower example are caused through the brush being well loaded with oil color; when strongly flexed, the brush leaves a certain amount of pigment where the pressure is least, i.e., the outside edges of the stroke.

LEARN TO USE THE BRUSH

If, after practicing for some time, the student finds that the brushmarks are still similar to those in the top demonstration, a larger brush should be used, about ½″ wide, well loaded with pigment, and strength exerted to flex the brush directly onto the canvas at various angles, but never in a weak or indecisive manner. In fact, the whole key to good oil painting technique lies in this first demonstration page. Until this is thoroughly mastered, it would not be of much value to students to tackle any other problem in this book.

It would be interesting, say, after a week's practice of one or even two hours a day, to try to delineate some simple object by the method shown in the lower illustration in Plate I. By this I do not mean that the student need worry at all about drawing any given object, but the circular feeling of a simple vase might be attempted with this vigorous brushwork, or an ordinary wooden box painted in this style, without any thought as to whether the perspective is right or wrong,

or whether the drawing is good or bad. You are out to conquer the essential foundation of all good oil painting—good handling.

DIRECT METHOD OF OIL PAINTING

If it be assumed that the student has now mastered what might be described as the decisive form of powerful brush handling, he can attempt something along the lines demonstrated in Plate II. Here, we see twelve demonstrations of painting in oil colors. I attribute a good deal of importance to this plate because it is a step forward in what is known as the direct method of oil painting, since each effect is obtained while the colors are still wet. Whether it is used for figure painting, still life, or sketching landscapes outdoors, this apparently elementary looking demonstration lays the foundation of simple, yet effective, oil painting. The same procedure was used in all the examples in this plate. In painting the lighter pigment on the darker ground, the brush should be handled with exactly the same freedom as shown in Plate I. Any indecision would create an illusion of timidity and lack of purpose.

The color example A is composed of yellow ochre mixed with small quantities of ivory black, white, and deep chrome. The ground color in B was made by mixing orange chrome with a little white and yellow ochre. The yellow tint seen in A was then painted on top of the wet orange-colored ground, but not so completely as to entirely obliterate the orange tint underneath.

The color shown in example C is composed of orange chrome mixed with a little white and permanent crimson. In D, the groundwork was painted of cobalt blue, mixed with a little white. The color shown in C was painted directly on this wet surface.

Example E is a pure tint of middle chrome straight from the tube, without any admixture of other colors. In F, the chief color is cobalt blue, mixed with a little white and permanent crimson. Middle chrome was painted directly on top of this prepared surface.

Example G is viridian mixed with a little white. H shows a groundwork of permanent crimson mixed with cobalt blue and a small quantity of white. The viridian as seen immediately above was painted directly on this purple ground.

Example I consists of black, burnt sienna, yellow ochre, white, and deep chrome. This color was painted directly onto a prepared ground of permanent crimson, as seen in J.

In the oil color marked K, the tint was made by mixing black, yellow ochre, deep chrome, and white. The example L is composed of black and burnt sienna, very little black being used.

PAINTING WET-ON-WET

These are only a few demonstrations of the possibilities of painting one color tint into another while both are still in a wet condition. It is comparatively easy to paint a surface, or touches of wet oil color on a dry colored ground, but when one is sketching outdoors directly from nature there often arises the necessity of getting a good result by direct oil painting. It should now be obvious to the stu-

dent that painting on top of, or into, paint—even though the ground paint is in a wet condition—presents a much more interesting surface, with far more vitality and color, than merely painting a flat tint on a white, barren ground.

After completely mastering the demonstrations in Plate II, the student should begin to see many possibilities of expansion in this one method only. These twelve examples are merely the starting point to further investigations. As color tints seem to be unlimited, so can the experiments of painting wet tints over (or into) each other be continued into almost countless numbers. Suffice it to say that the few which are shown in Plate II should excite the imagination of the would-be adventurer.

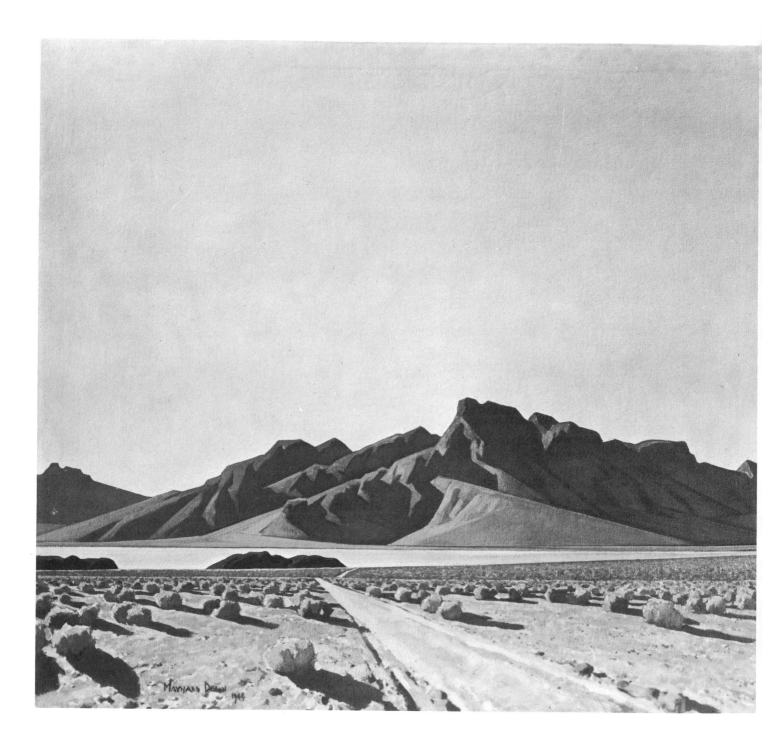

Desert—Southwest by Maynard Dixon.

It takes audacity to devote more than half of your painting to a cloudless sky, but the impact of this desert landscape depends upon that sky. The effect of great distance and luminous, transparent light—so typical of the desert—would be radically reduced by a more active, cloudy sky. However, it should be obvious that the sky is not a flat, monotonous tone, but contains many soft, blurred brushstrokes which give a feeling of atmospheric vibration, and which gradate very slightly from dark at the top to light at the bottom. This glow of light behind the mountains lends special drama to their jagged forms. Note how the mountains are painted in just two tones for their light and dark sides. The same is true of the desert brush in the foreground; each cluster of growth is painted as a distinct geometric form, with a light and shadow side. (Photograph courtesy *American Artist*.)

3

This chapter, like the previous one, deals entirely with the method of painting wet tints into a groundwork of colors which are also wet.

PAINTING WET-ON-WET WITH GRADATED COLORS

To refer to Plate III, example A is produced by mixing yellow ochre with white. Example C is a mixture of ultramarine blue, crimson, and white. B and D show five tints of graduated tones. The whole of the three surfaces of B, E, and D were in the first instance painted quite flat, with dark purple-gray. This dark gray, which represents the deepest tone or color in Plate III, is easily recognizable in the two top horizontal bands of color in B and D, in the trees, and in the shadow across the foreground in the pictorial landscape E. It is made by mixing ultramarine blue, permanent crimson, yellow ochre, ivory black, and white.

To make a painting similar to B, it is advisable to use four clean oil paintbrushes about ¼″ wide, so that each horizontal band of color can be tackled with a clean brush charged with the yellow tint A. The top horizontal band is left undisturbed, so as to form a separate tint.

The yellow ochre tint as seen in diagram A was painted very gently and lightly on the wet ground in diagram B—that is to say, the second tone from the top was painted quickly, and lightly, into the prepared wet surface of the dark ground. For the third tone from the top, a brush containing yellow ochre was pressed into the wet color with slightly added strength. The fourth tone from the top again needed a clean brush charged with yellow ochre, and even firmer pressure; and in the last layer of paint the color, being nearly the same tone as the original yellow above, was produced by painting heavily into the groundwork several times in order to get the necessary tint. It should be remembered that in every one of these tints the surface color is naturally influenced by the wet color below.

Diagram D presents precisely the problem shown in diagram B, the yellow ochre tint being substituted for the light bluish color of C. As mentioned before, the ground is painted all over with the dark purple-gray and the same process is followed, with the brush pressed heavily into the wet ground for the lighter tints, lightly to obtain the darker tones. The student is recommended to master thoroughly the painting of tones in diagrams B and D before beginning the central picture.

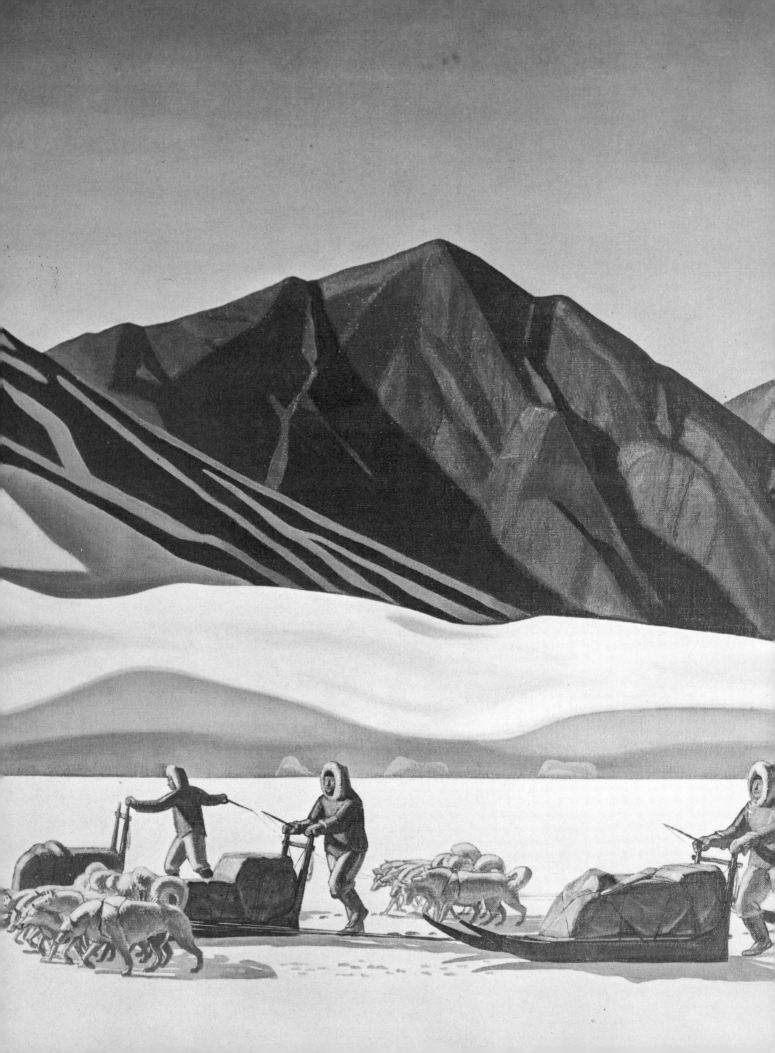

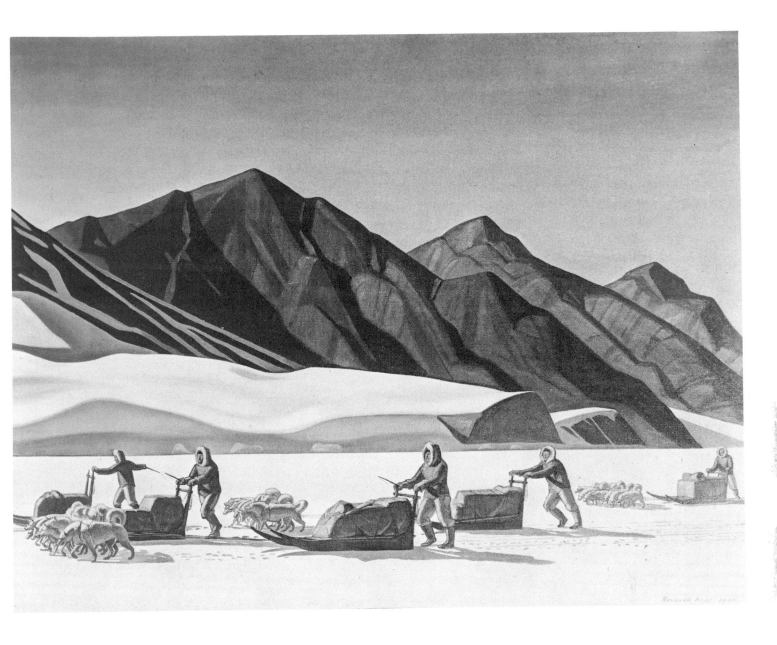

Polar Expedition by Rockwell Kent.

Painting mountains is an exercise in geometry. The artist must try to visualize the great jagged shapes as planes of light and shadow. This artist has painted the forms of the mountains in a series of flat tones, each tone corresponding to a separate plane. The shadow sides of the low, snow-covered forms at the foot of the mountains are particularly interesting. The artist has observed that shadows on snow often pick up reflected light from the illuminated snow nearby. Thus, the shadows are gradated from dark to light to dark again, in order to account for the reflected light. Mountain views are often more impressive if there are figures nearby so that the viewer can determine just how high the mountains are. (Photograph courtesy *American Artist*.)

PRACTICE IS NECESSARY

Later, obtaining the value of color tones you should proceed subconsciously. No mental effort is needed for the experienced painter to get varying shades of dark and light tints on a dark, colored, wet surface. The student will find, as in other problems, that steady practice is needed to get these various tints quickly and without loss of time. Copy the tones as seen in B and D for several days, not less than one hour each day. It is not necessary in every instance to use the same dark purple-gray for the ground color with yellow ochre or light purplish blue. Try other tints, but always use the darkest for the first painting.

It is surprising how quickly this subject can be mastered, and how soon one is able to feel the depth of a color tone before it is applied to a canvas. The degree of pressure required with the paintbrush to obtain the anticipated color tone eventually becomes quite easy to gauge, but do not forget that intelligent practice is absolutely necessary to arrive at this happy state.

TRY WORKING WITH TWO COLORS ONLY

The center picture in Plate III, marked E, is an example of producing pictorial representation with the use of two colors only. These two colors are chosen from A and the top horizontal band in B. The latter color is painted first over the whole of the picture, sky, houses, everywhere—one flat tint—done in the same manner as you might paint a door. It is quite exciting when commencing a picture to paint into this dark, dull surface.

Take a paintbrush mixed with the same tint of yellow ochre and white as seen in A, and paint as flat as you can, so as to get merely the silhouette of trees against sky. That is, you paint the sky first in a halftone tint without any surface variation, at the same time using flat color where the sky appears through the trees. *The experience gained by your mastery of the tone painting in diagrams B and D will prove invaluable at this stage.* It is necessary to be precise in the early stages of this painting; the artistic touches follow later.

Notice that the trees are the same tint as the ground painting, but the distant hill behind the cottage is a little lighter than the trees; therefore, suggest that next. The roof of the cottage is the same depth of color as the ground tint. Leave that untouched. Paint your cottage walls the same tone as the flat sky, also the light on the road in front. At this stage the whole design of this little picture will be quite evident, and its intentions clearly stated. With a clean brush, charged with yellow ochre (A), paint the light on the cottage walls strongly, but leave patches of halftone showing in places. With the same brush, suggest the miniature chimney, and put one or two fairly light touches on the farther end of the roadway, so as to get variation. Take another clean brush, and use yellow ochre for the formation of the light clouds in relation to the sky. With another brush, get a little variation in the tone of your sky, and a few delicate touches on the flat toned trees to suggest foliage, and create the feeling of atmosphere peculiar to nature.

By this time, the picture should be almost completed. It may be that you will discover one or two faults, which can of course be easily remedied, provided that you have worked simply and methodically.

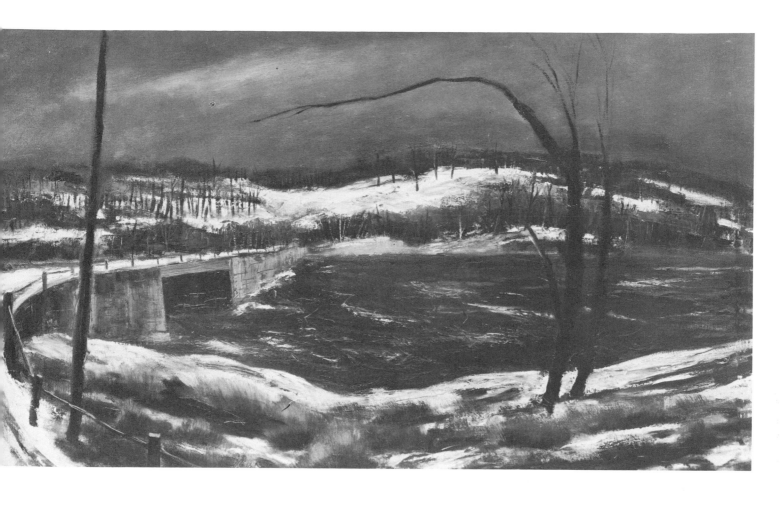

Bridge to Clark Island by William Thon.

A winter landscape frequently offers the opportunity to paint deep contrasts of light and dark, although the color range may be limited. Here the artist has chosen to play off the glowing white snow against the dark, moody winter sky and the blackish, turbulent waters of the river. Essentially, the composition consists of alternating horizontal strips of light and dark. Notice how the foreground swings the eye from right to left and then across the bridge back into the center of the picture. This movement is accentuated by the tree on the right, which bends and points—like an extended arm—to the left, where the viewer's attention is arrested by the dark, not quite upright pole, which leans back into the picture and keeps the viewer's attention from slipping out of the canvas to the left. Do not underestimate the importance of that pole: without it, the eye would continue moving to the left and out of the picture. Notice the thick, crusty quality of the paint, particularly in the passages of light snow, where the whites have been applied with considerable weight. (Encyclopaedia Britannica Collection of Contemporary American Painting.)

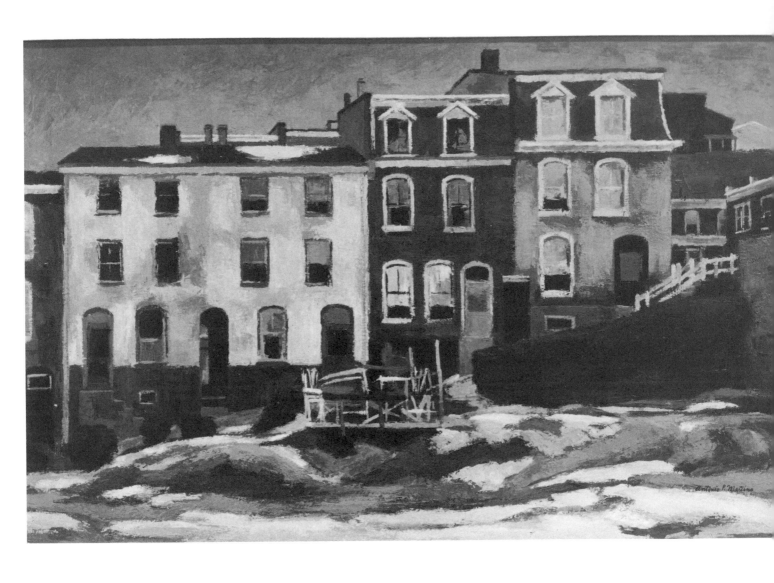

Four Houses by Antonio P. Martino.

A head-on architectural view often makes an interesting geometric pattern; but the painter must be sure to work for a pattern that provides sufficient variety. In this cityscape, each of the houses is a different shape, a different size, and even a different tone. Variety is also added by the irregular shapes of the snow and the soil in the foreground, which contrast with the geometric shapes of the buildings. Architectural painting need not be sharply detailed like an architectural rendering; observe how the painter has not painted in every single pane of glass and every single mullion, but has seen the windows as patches of tone and color. The textural variety of the walls is also interesting and the artist has applied his paint roughly to communicate this quality. (Photograph courtesy *American Artist*.)

Now, having completed this little picture, why not do several of your own compositions? They need not necessarily be landscapes; select any subject you like, with two colors only. Or you could try another landscape with the colors shown in demonstration D. Here, there is no positive yellow ochre to help you out, but all the same something interesting can be achieved.

I consider that this demonstration page is invaluable to the would-be painter in oil colors. It is a good scheme, after getting used to working in two colors, to add a third. For instance, in picture E the third color could be green: a strong bright green such as viridian, painted into the wet dark gray groundwork of the trees, would give a very happy blend of realistic tinting.

WORKING WITH TINTS In Plate IV, there are four color demonstrations dealing with painting wet colors into other colors.

The gray tint A was produced by mixing ivory black, flake white, and a little yellow ochre.

There are five horizontal bands of color shown in diagram B. They are made by mixing the following tints (top to bottom): permanent crimson, ultramarine blue and white; chiefly white with a small quantity of ivory black and yellow ochre; burnt sienna and white; viridian and white; and yellow ochre and white.

In color diagram C, the original groundwork is precisely the same gray as used in A. On this wet ground, the five tints seen in diagram B were painted. Every one of the surface colors was slightly modified by the color of the groundwork, which is left undisturbed immediately above the lowest portion of yellow ochre.

Some of the tints which stand out strongly show a definite formation. This was achieved by loading the brush with plenty of oil color. The less oil color used in the brush, combined with a fairly light touch, the less obvious it will appear on a wet groundwork. This theory is clearly demonstrated in practice on Plate IV.

Diagram D is an example of rich colors, with the possibility of exploiting them in some pictorial representation. The groundwork was first painted all over with the same gray as seen in A. The deepest color on the highest portion of this sketch is made with permanent crimson and a little vermilion (middle tint). This color was painted over the wet gray, about two-thirds of the area space, downwards. Next, the darkest tree forms behind were painted over the crimson tint with some chrome orange; then the lighter colored trees were painted with deep chrome, applied on top of the wet orange chrome.

For the greenish yellow field in the foreground, middle chrome was painted directly on the gray ground, and a mixture of crimson and vermilion was painted on top of the greenish yellow field at the foot of this picture. *Students should remember that all these colors were laid on—one on top of the other—in a wet condition.*

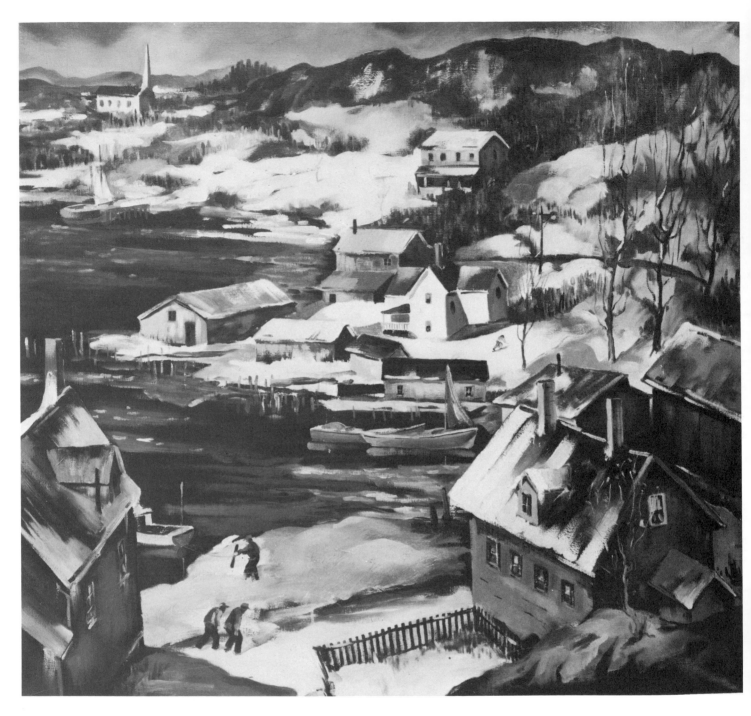

Fishing Village by George Schwacha.

The artist's choice of his vantage point is particularly important in organizing a successful landscape. Many of the landscapes in this book are painted from a relatively low vantage point so that architecture or trees loom up into the sky. This view of a coastal village, on the contrary, is painted from a high vantage point—presumably from the side of a hill—looking down into the village, and thus eliminating all but a thin strip of sky. Such a subject is difficult to compose and the artist has wisely decided to frame the composition by placing houses in the lower right- and left-hand corners, pointing the viewer's eye directly into the center of the picture; the converging perspective of these houses channels the viewer's eye. Observe how the darkness of the water reflects the winter sky. It is also important to note that the snow is not uniformly white, but is broken by large patches of shadow. The reader must develop a thorough command of perspective. (Photograph courtesy *American Artist*.)

MIXING COLORS

It is well, at this stage, to study the possibility of making refined and harmonious colors which, apart from their own undoubted importance, can be used as peacemakers between two or more colors that may clash violently against each other. The novice in color painting invariably suffers through lack of knowledge as to how to mix tints. It is true that some students may possess an instinctive feeling for getting the color tints they desire, but one can save a lot of time and worry by deliberately disciplining oneself to a systematic way of mixing colors. By doing so, the student will soon discover the possibilities of obtaining a very large color range from a few inexpensive, and indeed modest, pigments.

USING BLACK TO MAKE COLOR TINTS

In Plate V, I have painted sixteen tints in rectangular form, all of which are made from quite ordinary colors. On looking at this page of color examples, the student will notice that every tint is free from garishness or crudity, and that the last four tints (D, H, L, P) are ultra-refined and extremely sensitive in tone. It may be interesting to some readers to know that each one of these tints has a proportion of ivory black in the mixture of the colors.

Starting from A, the color here is pure ivory black. B is ivory black mixed with white. C is the same with a little yellow ochre added. D is the same color as C, mixed with more white.

In the next row of colors, beginning with E, ivory black is mixed with light red. F is the same with white added; notice how white, when mixed with E, clearly shows the red tint, which is somewhat disguised in E. G possesses the same colors as F with an admixture of yellow ochre and a little more white. H is precisely the same as G, but lighter in tone owing to the addition of white.

In the next line of colors, beginning with I, ivory black is mixed with viridian. J is the same color with white added; how quickly the white oil paint assists in bringing out the original color of viridian, which almost loses its identity in diagram I! K is the same in color foundation as J, with the addition of yellow ochre. L is precisely the same as K with more white added.

M is made of ivory black and ultramarine blue. N is the same as M with the addition of white; here again the white paint helps to produce the disguised color of M, which is blue. The color diagram O is the same tint as N, with the addition of yellow ochre. And, of course, the last diagram P is the same, but with more white added.

MIXING COLOR TINTS In Plate VI, there is a very interesting demonstration of the mixture of simple color tints. Example A, which is gray, was made with black and white, mixed with a little ultramarine blue and yellow ochre. Example C is a pure tint, straight from the tube of deep chrome. Example B was obtained by painting the gray tint A as a ground color, and then painting the pure deep chrome tint right over the wet gray ground. The lower tint D was produced by painting the ground color with pure deep chrome, then painting the gray directly over this wet ground. Tints B and D are very beautiful in color, yet they are obtained from almost raw elements—a cold raw gray and a crude yellow chrome. As soon as two strong opposing colors are blended, they produce a delicious harmony.

There are many ordinary tints which can be mixed with a little judicious thought. For instance, if one happened to run out of yellow ochre, an almost exact replica can be made by mixing deep chrome, ivory black, vermilion, and white. Needless to say, very little vermilion is needed, otherwise the tint would appear too warm in color.

There are also many greens which can be made by the admixture of various blues and yellows. It is sometimes very disconcerting to discover that a favorite green is missing from the oil paintbox. Though it is true that one cannot make a color as intensely brilliant as emerald green or viridian, yet, for all ordinary purposes, most interesting greens can be manufactured by the adroit use of opposing colors.

NEVER THROW AWAY PAINT When dealing with the unfinished colors left on the palette at the end of a day's work, it is a good idea to mix most of the light tints together, leaving out anything in the nature of a dark tone. Sometimes by doing this, a beautiful gray will result. Various dark colors can be mixed together, occasionally producing a dark gray of an almost indescribable tint. Other colors, besides those with a tendency towards gray, when treated in this manner produce interesting color suggestions.

No colors need ever be wasted. An ordinary enamel pan will hold all the colors scraped off the palette. Water is then poured in until the highest portion of the paint is covered, after which the pan can be placed on one side, ready for use at a later date.

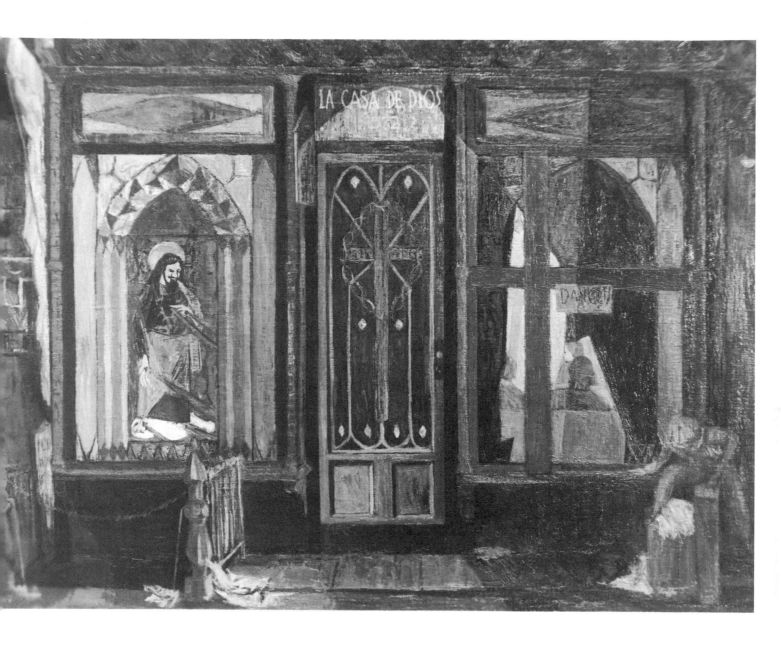

La Casa de Dios by Steve Raffo.

A cityscape need not always be a panorama of buildings and streets; the urban landscape provides many fascinating closeups of architectural material. In this storefront church, the artist has found rich texture, intricate geometry, and an interesting combination of lighting effects. Not only does light appear *through* the windows, it also falls on the doorway from a distant light source, making a curving patch of light. The effects of broken light in the urban landscape are worth studying. And painting the texture of stone, brick, concrete, and wood are excellent practice in brushwork. (Photograph courtesy *American Artist*.)

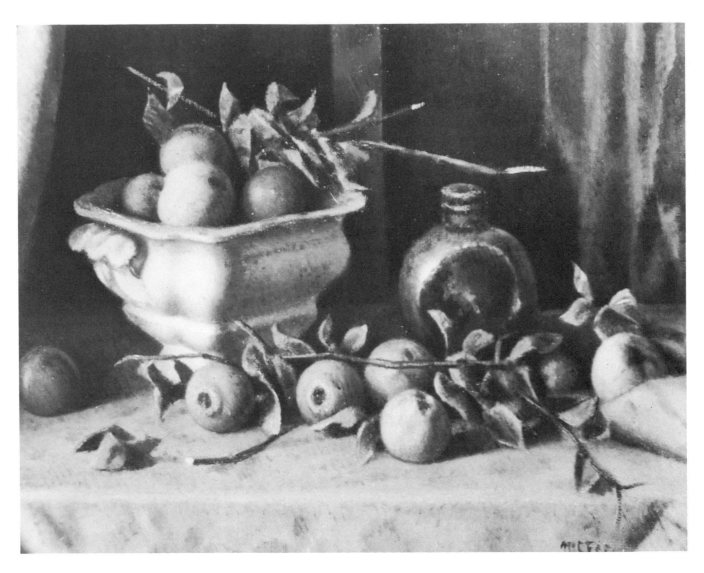

White Dish With Green Quinces
by Henry Lee McFee.

The secret of a successful still life is often to allow one large shape to dominate, while all other shapes are clearly secondary to the one big shape which is the center of interest. Thus, the bottle to the right simply acts as a counterbalance to the white dish, while the scattered spheres of fruit in the foreground are there to provide a "base" for the composition. Beyond the white dish is deep shadow, which accentuates the flash of light on the left hand side of the dish and on the globular fruit. Like the old masters of still life, the artist has clearly defined the direction of the light, which comes from a single source, and thus emphasizes the roundness of each shape. (A single light source is the most effective way of emphasizing three dimensionality.) The texture of the painting is beautifully unified by the softness of the artist's brushwork: there is not a single hard edge to any form in the painting. (Courtesy Pepsi-Cola Company.)

5

STILL LIFE

Still life painting is so large a subject that it needs a separate book to do full justice to its manifold aspects. Although the advantage of having still life objects placed in a stationary position is not to be despised, there is always the danger of losing a certain freshness of brush handling, owing to the opportunity given to the artist to try to produce an exact facsimile of the original subject. Under these conditions, the painting is likely to look stale and uncertain in treatment, unless the artist has had very considerable experience in still life work.

CONCENTRATE ON OVER-ALL MASS

Students are advised to go directly for definite tones, in addition to the main essentials of drawing, and ignore any detailed expression until they have completely mastered the main aspects of the subject. Conscientious delineation of subdued detail nearly always ends in over-accentuation at the expense of the main theme. Later, when experience ripens, students will have less difficulty in representing minor portions of a painting, without destroying the broad effect of the picture. It is well, therefore, for the first year at least, to paint boldly, without fear of failure. Failures should not matter much; courageous painting matters a lot.

BEGINNING A STILL LIFE

Plate VII illustrates the first stage of a still life group. The pitcher represents age or antiquity, and the pink teapot is a modern utensil. One does not associate pretty or cheap color effects with the character of an ancient pitcher, but the teapot possesses a lighter charm.

In the preliminary stage, the subject was depicted in charcoal outlines, but it was not sprayed with fixative, as the loose charcoal blends very well with the different tints seen in the picture—especially the background material. For the first painting, the various colors were well diluted with mineral spirit (one can also use turpentine). The following colors were used:

Dark background: ivory black, burnt sienna, and a little ultramarine blue.

Blue cloth: ultramarine blue, purple, and a little white.

Pitcher: ivory black, burnt sienna, and a little light red.

Teapot: rose madder, also cobalt blue mixed with rose madder.

Foreground reflections: ivory black, burnt sienna, rose madder, and a little ultramarine blue.

LIGHT AND SHADOW A good deal of light and shadow is noticeable in the first stage. Except in the blue cloth, no white paint was mixed with the various colors. The effect of light was obtained by painting the two foreground objects, and the foreground itself, quite flat all over, with their darkest shadow colors, and then using a clean rag dipped in mineral spirit to obtain the halftone lights seen on the right-hand side of each object and in the subdued reflections below. This method is fully explained in Chapter Seven.

HIGHLIGHTS In the final stage (Plate VIII), colors similar to those used in the first stage were mixed with flake white. The greenish yellow color on the higher part of the pitcher can be made with ivory black, deep chrome, a little yellow ochre, and white. The gray markings on this object, both in light and shadow, are made of ivory black, yellow ochre, and white. Other markings show a little light red, light purple, and yellow ochre, each mixed with white. By making a careful examination of the lower end of the pitcher, the student will see that it is free from any detail or disturbing highlights, so as to assist in keeping the spherical feeling of the object.

Rose madder was used together with white and a little yellow ochre to get the decided light on the teapot, while alizarin crimson, mixed with cobalt blue and white, helped to give a good solid color in the shadow portion. The highest lights on both objects are composed of flake white with a touch of yellow ochre.

It should be remembered that any colors which are used in the final painting will never be affected by the ground tints depicted in Plate VII. The canvas is only stained—not painted solidly—with oil pigment, and, thanks to so much running mineral spirit, the final painting can be started within a few minutes after staining and wiping out, or immediately if necessary.

Flowers on Blue Cloth by Meyer Abel.

The richness and profusion of a bouquet of flowers needs a simple background; a more complex background would conflict with the flowers and neutralize their richness. In this lively flower painting, the artist has simply divided the background into a series of vertical panels of light and dark, enlivened by rough, free brushwork, which subtly lightens and darkens the background in various places to provide the right tone of background for the various parts of the bouquet. The vase is also simple, as is the drapery on the table top. Note how the perspective of the table top—the sides slant inward—leads the eye upward into the cluster of flowers; even the direction of the folds carries the eye where the artist wants it to go. The vase is a generally dark, unobtrusive shape, enlivened only by a soft highlight. Thus, the blooms are allowed to dominate the picture completely. (Courtesy International Business Machines Corporation.)

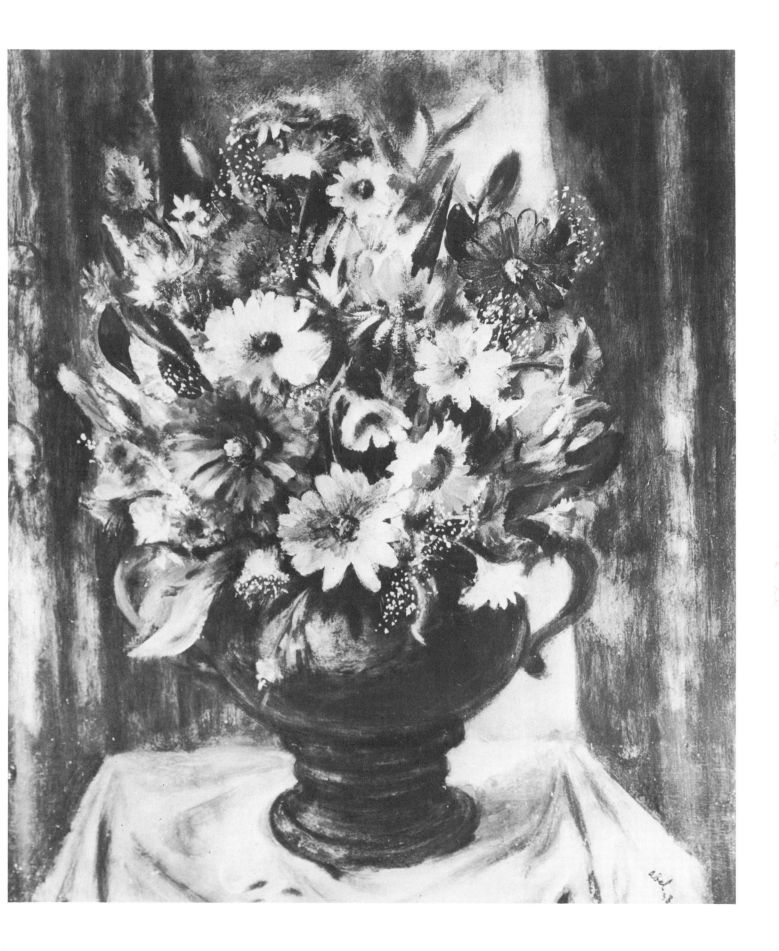

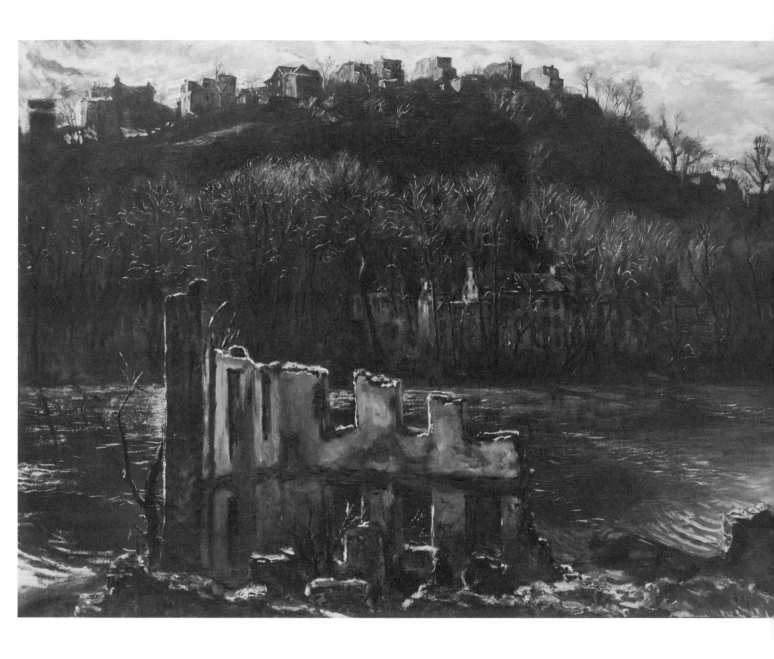

Ruins Along the Schuylkill by Francis Speight.

The artist was obviously fascinated by the delicate wisps of light that appeared on the branches of the trees, on the edges of the ruin, and on the crests of the waves in this landscape—which was obviously painted late in the day or perhaps very early in the day, when the sun was low in the sky and behind the distant hill. Although this painting is predominantly dark, it appears to contain a surprising amount of light, all applied in the form of vibrant little strokes which enliven the entire canvas. These notes of light are not arbitrary, but are the product of very careful scrutiny. For example, one can perceive the precise movement of the water and the movement of the wind through the distant trees—all expressed by these little strokes of light. Notice how the distant hills are almost entirely in darkness in order to provide a proper background for the lightstruck ruin and trees. The water, too, is almost entirely dark, reflecting the darkness of the distant land mass. Remember that water is not always a pool of light, but is simply a mirror that reflects its surroundings. (Photograph courtesy *American Artist*.)

6

SPECIAL OIL SKETCHING SURFACES

It is occasionally very good discipline for students to practice oil painting on surfaces other than canvas or wood. The more experience students get in the various ways of handling oil pigments, and in the use of different materials, the easier it will become for them to concentrate later on some definite form of painting. As for the artist who has been used for a number of years to painting thinly, and who possibly has painted very well indeed, he can derive no harm from experimenting with thick painting on some new and different type of surface.

PREPARING CARDBOARD

Plate IX shows the first stage of a landscape which is painted on cardboard. This material is very cheap, but useless unless properly prepared for oil painting.

In this instance, the surface was prepared by using whiting, ordinary water, gelatin, and sand. The fine sand used for this preparation should not be taken from anywhere near the sea, otherwise the salt element would be very injurious to the oil pigment. Inland sand is the best and quite reliable. There is no set rule as to the general proportions of the materials used to get the surface, but in this case a tumbler and a half of water was poured into a saucepan, and while the water was still cold, a pound of whiting was added. This was placed over the gas, and slowly heated (but not allowed to boil), until the whiting was dissolved in the water by gentle stirring. Then some ten to twelve flakes of gelatin were placed in the saucepan; these melted very quickly, and about two teaspoonfuls of very fine sand were added.

After these were well mixed, the cardboard was placed on a flat surface, and a large brush, about 2″ wide, was used. The hot mixture was well stirred with the large brush, and the whole of the board was painted firmly and briskly, backwards and forwards. As the sand sinks to the bottom of the saucepan, it is necessary to stir frequently. The other side of the board was then treated in the same manner and left to dry. It is necessary to prepare both sides of the board, otherwise it will warp badly.

One can also buy the new acrylic gesso, for convenience, and mix it with sand.

PAINTING ON CARDBOARD

For outdoor sketching, or for suggestive subjects, this cardboard with a sandy surface forms a very good texture to which the oil brush will cling and leave interesting surface marks (Plate IX). It is almost like working on an old canvas

Afternoon Sun by Stephen Etnier.

A specific time of day is best defined by the quality of the light, since the sun is in quite a different position at each time of day. Here, where the artist has sought to capture the effect of afternoon sun, the sun is already dropping low in the sky and sending its horizontal rays across the water, backlighting the houses and the figures, and simply touching their edges with light accents. The beginning painter should study the typical light effects of different times of day, noting which light effects are most effective for conveying form and which are most likely to destroy form. Thus, he will find that backlight—typical of early morning or late afternoon—is most likely to emphasize silhouettes, while the light of mid-day is more diffused and more likely to make forms evanescent. Notice how the quality of the late afternoon light sharply defines the light and shadow planes of the wooden forms in the foreground. (Photograph courtesy *American Artist*.)

which has previously received many coats of paint. The principle applied in this landscape is that seen in Plate XXVI. The sky was washed in with yellow ochre and white, fairly thinly painted. For the distant hills, the colors used were purple and blue, with delicate touches of viridian and yellow ochre. Light purple, burnt sienna, and plenty of yellow ochre were used in the middle distance hills. In the foreground, deep purple, pure burnt sienna, black, and touches of green were incorporated to obtain the resulting tone.

While all the delightful warm tints of the paint were still wet, the cool surface colors were added. The artist derived much pleasure when completing the sketch (Plate X), as the colored groundwork seen in the first stage assisted in giving the final color touches their true tones.

It is hardly necessary to mention that the colors used in the first stage, such as yellow, dark brown, deep purple, and black, became merged with the color placed on top, the two colors thus becoming one. From the preservation standpoint, it is important to remember (since the picture should retain its natural color and tone for a long period) that very little of either linseed oil or copal varnish is used as a medium in the oil pigment.

It is to be hoped that the student will go to the trouble of copying this, as well as many other picture demonstrations in this book, and that the principle of placing one color over the other, and making the two colors one, will also be applied to his own original sketches done for his own personal pleasure.

PREPARING BUCKRAM Another device for sketching in oils, and one which is often very beneficial as regards the feeling of paint, and the character of oil painting generally, is to paint on brown buckram. This material can be purchased at fabric shops, and is generally used by dressmakers for stiffening collars. It is remarkably cheap, and very effective for sketching purposes. The buckram should be cut to the size required, and then attached to cardboard or wood, or some appropriate material, with white glue. It is just as well to coat the outer sides of the cardboard or wood with glue to prevent warping.

Owing to the doubtful origin of the surface of buckram, it had better be well prepared before painting with two or three coats of pure size or clear acrylic medium. There is no guarantee that it will assist in keeping colors from any sort of impurity, but the certainty is that any student whose oil painting is inclined to look slippery, or lacking in robust texture, must—when painting on buckram—achieve some definite oil paint surface, due almost entirely to the coarse texture of the buckram. It is very pleasing, when working on a well-sized buckram surface, to find how readily the paint adheres, and gives a special sparkle of its own, caused by the rough surface of the material.

PAINTING ON BUCKRAM Plate XI shows a most excellent reproduction of the first stage of a sketch on buckram. The nature of the material is easily seen on the extreme right-hand side, as here is the actual color of the buckram, and it is also noticeable in the darker

hues of the sky. The subject being a street scene in Rouen, which is well known as a place of much antiquity, the artist tried to render the feeling of antiquity by originally painting deep and rich colors on the buckram. If the coarseness of the material prevents the brush being handled easily, there is no reason why plenty of medium should not be used since one is out to achieve a good sketch, and nothing else matters.

There is a considerable quantity of turpentine, mixed with a little copal varnish, used in the medium for painting the sky. The light on the roof, towards the left, was painted with extremely thick pigment. Here, the texture of the buckram was invaluable, as the colors clung so easily and became part of the material below. As regards broken edges, the student has only to look at the highest part of this roof, where it is silhouetted against the sky, to notice that the textural nature of the buckram is essentially useful in obtaining a soft, and yet fairly definite, line. In other places, such as the dark silhouette of the roof against the sky, a considerable quantity of liquid medium was used, in order to emphasize the clearness of the dark tone against the sky.

What is so pleasing in a sketch of this type is the speed with which it can be achieved. For instance, in the central building (a little to the right) touches of gray only were placed in the shadow, the buckram being left almost entirely in its original color scheme.

Buckram is not used for the serious picture. It is only a means to an end. The same quality of pigment which is so easy to get on this material should be achieved on a good canvas of stout texture, when one is working indoors in the studio from the original sketch.

Plate XII shows the final stage of *A Street Scene in Rouen, France,* done on buckram. In this instance, the sketch was carried so far that it resembles the appearance of a finished picture. The word "finished" is, of course, used advisedly. There is no real finish to any picture if the artist can still see further possibilities of improvement. An apparently finished sketch may be put away by its painter for a year or more, when the artist invariably finds on bringing it out again for inspection that some improvement can be made, either through additional painting or by painting out detail and simplifying the general design.

The textural surface of the buckram gave great assistance in suggesting detailed drawing, although no actual painting of detail was done. This is particularly noticeable in the vertical passage of light on the house (center of sketch).

In the Woods by Sidney Laufman.

To capture the diffused light and intricate texture of the woods, the artist has used a rich buildup of small, rough, ragged strokes. Without rendering a single leaf, the artist has caught the lively texture of masses of foliage, tree-trunks, rocks, and irregular ground. The forest is not dark, impenetrable, monotonous, but is frequently broken by lighted patches of sky that appear between the leaves and branches. Thus, some parts of the trunks and branches are caught in light, while others are in shadow. In the same way, there are light and shadowy portions of the foliage masses. The paint is dry, applied with stiff bristle brushes. (Photograph courtesy *American Artist*.)

7

WIPING OUT

Wiping out oil paint with a rag on a specially prepared surface to achieve artistic results does not seem to be generally known among artists. In the ordinary way of painting, minor defects are often scraped or wiped off (not from a prepared surface) with a view only to removing some offensive or incorrect painting. Wiping out has several advantages—one in particular is the fact that by this means the painter is able to resurrect or revive an old sketch or picture which in his view has failed. Taking the artistic failure as the motif, the artist will have no difficulty, when using the method advocated in this chapter, of discovering several entirely new ideas that should easily change a pictorial failure into an artistic success.

LOOSEN UP YOUR TECHNIQUE

For instance, if the sketch or picture in question is very hard or tight in its manner of painting, without any suggestion of vaporous atmosphere or lost edges, the subject should be painted again on a small scale, but this time quite flat, like a poster, on another canvas, with not more than three colors, and then the highlights should be wiped out with an ordinary linen rag soaked in mineral spirit or turpentine. Sometimes the results are quite astonishing. In any event, the suggestions obtained are invariably artistic, and should stimulate the painter to get several creative ideas, any one of which could be transferred with advantage to the original picture.

WIPING OUT ON CANVAS

Plates XIII and XIV show two examples of wiping out oil color on canvas. In the top portion (A) of Plate XIII, the two colors adjoining each other were used in the two pictures seen below (B and C). There is only one color in each picture, although several tones are indicated. The top left color in A was made with viridian, a little ivory black, and yellow ochre. The color on the right is composed of purple, a little black, and yellow ochre. The purple was made with permanent crimson and ultramarine blue. Turpentine and a little linseed oil were used as a medium with the color in Plates XIII and XIV. It is noticeable in the two reproductions below (B and C) that the surface of the canvas is fairly coarse, more especially as these two reproductions are the same size as the original painting.

The dark green tint above (A) was also used for the whole of the surface of the reproduction below (B), and like the reproduction above was painted as flat

as possible, covering the whole of the picture. Then an ordinary linen rag was wound around the first finger, and dipped in pure turpentine. On this flat, opaque surface the sky was attempted by pressing fairly lightly and quickly, and, although it occupies so small a space, it was necessary to dip the rag in turpentine almost after every pressure on the canvas. This halftone feeling was also applied to the foreground, beginning at the top left side of the picture, and working vertically downwards and then across the road. It is also very lightly applied to the surface of the building on the right, so as to suggest, in a faint, delicate manner, some feeling of windows and doors. The last and final touches, requiring an absolutely clean rag, were on the distant buildings, which, being exposed to the light, stand out vividly against the dark surroundings; also on the road at the foot of the buildings, and on a light patch on the road, at the lower end of the picture towards the left.

For one or two other touches it was necessary to use a fingernail, by pressing it against the rag so as to obtain a line which had an etched appearance. Through using the fingernail, and working with a clean rag, the color edges can be sharpened to be almost as hard, or clean cut, as the artist may wish. This helps considerably in accentuating certain portions of the picture, and so affording a contrast with the more indeterminate portions.

WIPING OUT CAN SUGGEST SUBJECT MATTER

The adjoining painting on the right (C) was begun without any idea in the artist's mind as to what the subject matter would be. By vertical pressure downwards with a clean rag on the flat purple-gray tint, the suggestion of a tree trunk appeared, and so the sketch was carried on with that thought in view, i.e., a woodland subject. Naturally, there are accidental touches, and if they have any value in giving expression to the picture it is just as well for the artist to leave anything of that sort untouched. It seems quite possible that, if one had a fair-sized canvas (or canvases) and a limited number of colors, and went outdoors solely for the purpose of sketching old walls and carefully copied the stains caused by centuries of use and disuse, by the wiping out method, many pictures could be evolved under such conditions. It would be an interesting way of demonstrating another aspect of outdoor sketching.

USE WIPING OUT TO EXPERIMENT

Larger compositions could be attempted on the same lines as the two miniature landscapes in Plate XIV. There is no doubt whatever that in this way an artist can be greatly helped who has been working for one or two months at an important picture, since there is a tendency to become stale, or so preoccupied after continuous concentration on one subject, that further progress appears almost impossible. The same subject on which he is working could be treated in two or three colors on a fair-sized canvas, the lights rubbed out according to the lights of his serious painting, and the shadows left severely alone. The accidental suggestions of wiping out, or rubbing out, in this manner should suggest to the artist further possibilities for the picture to which he has devoted serious attention.

In Plate XIV are two more pictures (A and C) but more advanced than those seen in Plate XIII. So that the student shall thoroughly understand the working of these fairly simple sketches, the original colors of each picture are shown on the right (B and D) for the same purpose as the two tints seen above the sketches in Plate XIII.

At a first glance, anyone who has not tried this sort of experiment before may be amazed to know that the three vertical colors in diagram B are the only colors used for the adjoining picture (A). So many subtle tones appear during the washing out of the color with turpentine, and the range of tints increases so easily, that it seems incredible that three colors can give such variation in so small a picture. The three colors in B are: pure cobalt blue for the first vertical line; cobalt blue, yellow ochre, white, and ivory black, for the second or central color (very little yellow ochre being used); for the third vertical color on the right a mixture of deep chrome and white.

The picture (A) is painted in exactly the same method as those in Plate XIII. The sky and the landscape were first painted quite flat, the former (including the unseen hills) with a coat of cobalt blue, and the landscape below with the same tint as shown in the vertical color on the extreme right diagram B. The sky was then repainted, the central vertical tint being used, but not too thickly, otherwise the color below would lose its value.

At this stage, there were only two colors discernible, the middle vertical tint and the dark sage tint. There was no suggestion whatsoever of drawing, no cloud formation, no light touches in the foreground, and no hills. An horizontal line right across the lower part of the picture showed the division of the sky from the earth. Next a clean rag was used as before, dipped in mineral spirit and applied to the space occupied by the sky. The wiping out of paint soon suggested cloud formation. The lower clouds had one or two very sharp, light touches, which were obtained by use of the tip or nail of the finger. The middle distance between the foreground and distant hills was then treated, the rag being adjusted two or three times so as to wipe out nearly all the paint—leaving a light and very subtle color. The hills were hardly touched, except in the central part. The dark brown foreground was treated in the same manner.

The three tints used in the lower diagram (D) are pure orange chrome, as seen in the first column; a mixture of permanent crimson, ultramarine blue, and a little white for the second color; and burnt sienna, with a little ivory black, for the color on the right.

In commencing the picture on the left (C), the first thing of importance was the flat painting of chrome orange over the whole of the bridge and foreground, but not the water. Incidentally, it might be mentioned that it is worthwhile, sometimes, for the student to suggest slightly in pencil the chief contours in a subject of this sort, although the less drawing before painting the better, because there is a tendency when making a preliminary drawing to destroy the creative impulse which grows with the more or less accidental touches of the paint rag.

The cobalt blue from diagram B was painted right across the top of the picture, about ½″ downwards, and was also used for the water seen underneath the arches and in front of the bridge. The trees were painted quite flat on top of these

Monhegan Harbor by Jay Connaway.

To dramatize the massive shape of coastal cliff and rock formations, back lighting is particularly effective. Here, the glow of light from the sky in the distance throws the cliffs into dark silhouette and emphasizes their brooding majesty. The sea, too, is dark, though it is relieved here and there by touches of white foam. The paint is applied flatly and decisively, with large, free strokes, which harmonize with the rockiness of the terrain. The small figure in the foreground is important because he gives the viewer a sense of scale; without him, one would not be quite sure of the size of the distant cliffs. (Photograph courtesy *American Artist*.)

wet colors, with the darkest tint seen in diagram D. The middle tint of purple was then painted, also quite flat, to represent the shadows of the bridges and underneath the arches. The same tint was also used in places on the dark tree which rises upwards through the center of the left arch, and on the trunks of the trees. It was very exciting, after this simple preparation, to begin wiping out, always remembering that each color was painted as flat as possible. As the dark tints are invariably laid on first, the artist when wiping out naturally attacks the desired highlights in the subject. In this case, the light on the bridge, also at the foot of the foreground and on the extreme left, with a few gentle touches on the water and the sky, were all that was required.

SUGGESTION, NOT DETAIL

It should be clearly pointed out to students that the chief thing to aim at is not meticulous detail, nor a great deal of careful handling with the rag, but a charming suggestion, or a sinister suggestion, or any other suggestion, which is gained as the result of purposely wiping out portions of dark, wet paint with a rag on a preconceived surface. It would be quite foolish for a student to try to copy exactly either of these two pictures. It would be very much wiser to try to imitate the spirit of the subjects, and with apparently accidental touches to get a result somewhat similar to the original.

Then, after acquiring the technique of rag handling or wiping out, students can have the delightful pleasure of evolving many ideas of their own. Naturally, there is no limit to this technique.

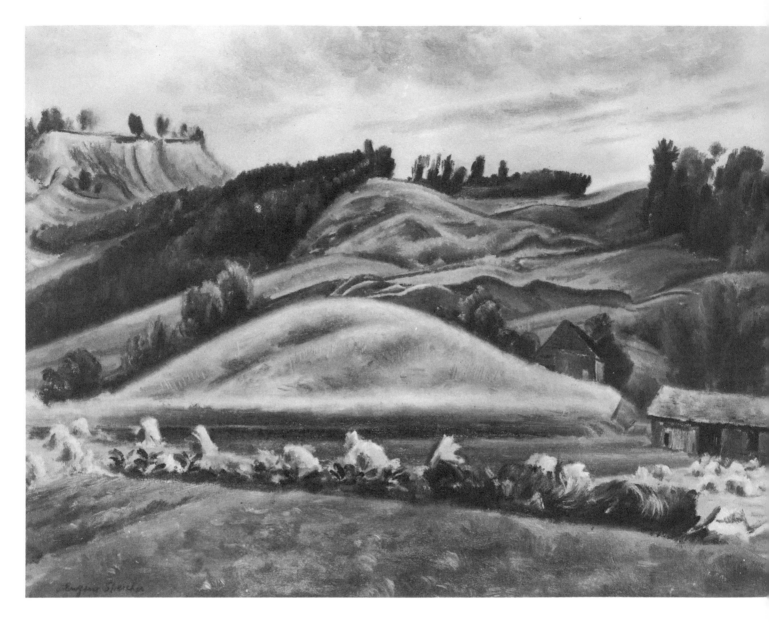

Murray Bay Landscape by Eugene Speicher.

Faced with the complexity of an undulating landscape of rounded hills and wandering clusters of trees, the beginning painter may wonder how to unify the mass of details. In this canvas, the artist has simplified the landscape into a series of rounded forms which he models in light, halftone, and dark, just as he would paint the shapes of the human figure. Each form has a distinct identity, though the rounded forms echo one another and thus achieve unity. The trees are visualized as wedges of dark—not individual trees, but masses of color and texture —which break through the rounded shapes of the landscape. Thus, by visualizing shapes rather than details, the artist has retained a boldness of conception which organizes a subject that might otherwise be hopelessly diffuse. (Collection Whitney Museum of American Art.)

8

GESSO
PANELS

In the early days of oil painting, pictures were done on wooden panels primed with white gesso. Pictures painted in this manner have successfully withstood the test of time. Nowadays, most panels are made out of Masonite or a similar hardboard.

ADVANTAGES OF GESSO

Two distinct advantages are gained by the use of gesso on a panel. *First,* the purity of white gesso gives very considerable help in retaining the brilliancy of oil colors painted over the white ground. *Second*, gesso after being coated with size or oil pigment is impervious to damp or climatic conditions, and when used on hardboard will protect it from all normal accidents.

There is no occasion in these days to go to the great trouble of preparing gesso powder, with its attendant difficulties; moreover, to successfully prepare it would take a considerable part of one's time, which could be far better utilized in more profitable ways. I have thoroughly investigated gesso powder, as sold by art supply stores, and can find no fault with it, since the manufacturers take all the necessary trouble to perfect the material.

PREPARING GESSO PANELS

For painting on panels, the gesso powder can be mixed in a few minutes by adding cold water and grinding well with the palette knife. The gesso, after being mixed with water, should be of the consistency of fairly thick cream. If it is too liquid, it will mean the application of several coats on the panel, and a great deal of time lost waiting for each coat to dry. I usually find that the ordinary panel needs two coats of gesso before the picture is begun. The second coat of gesso should not be applied until the first coat is quite dry, otherwise the surface will become uneven and unsatisfactory.

Acrylic gesso, which comes in liquid form, is even simpler to apply—either straight from the can, or thinned with water.

In Plate XV, on the top line, is a tint of middle chrome, which is painted directly onto the actual canvas (A), the canvas having previously been glued firmly on a wooden panel. The same color was used on the right-hand side (C), but it was painted over a ground prepared with pure white gesso. These two examples are given to show the vivid contrast when using the same color under different conditions, the first of which is painted directly onto the primed canvas,

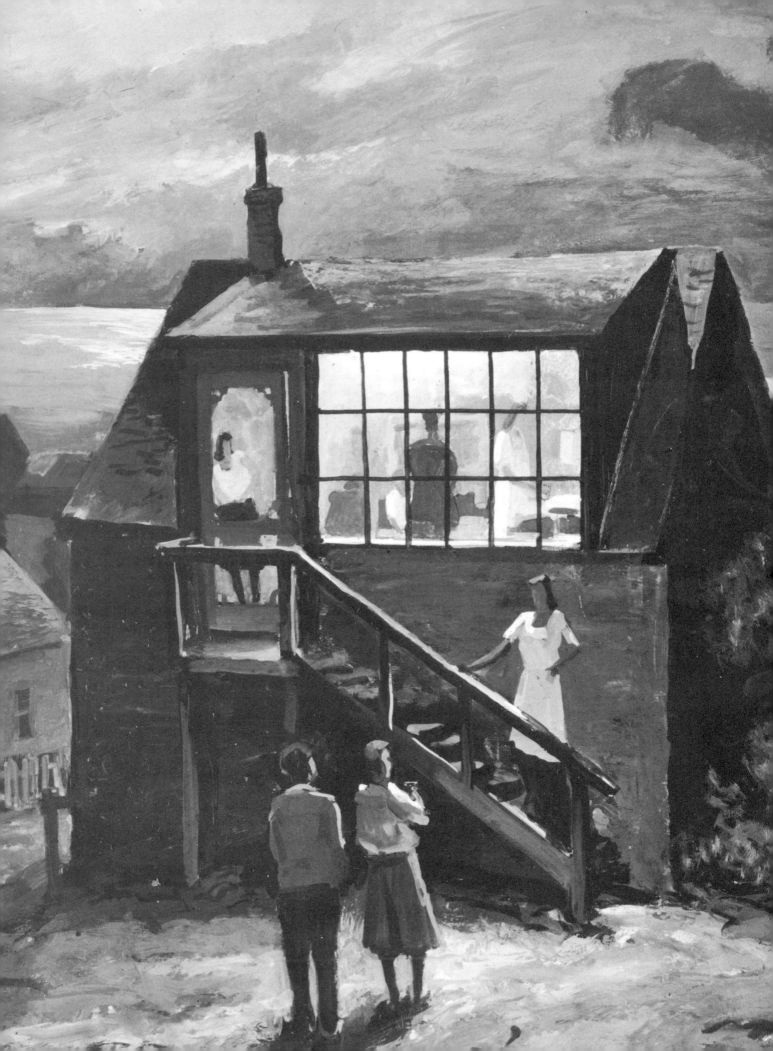

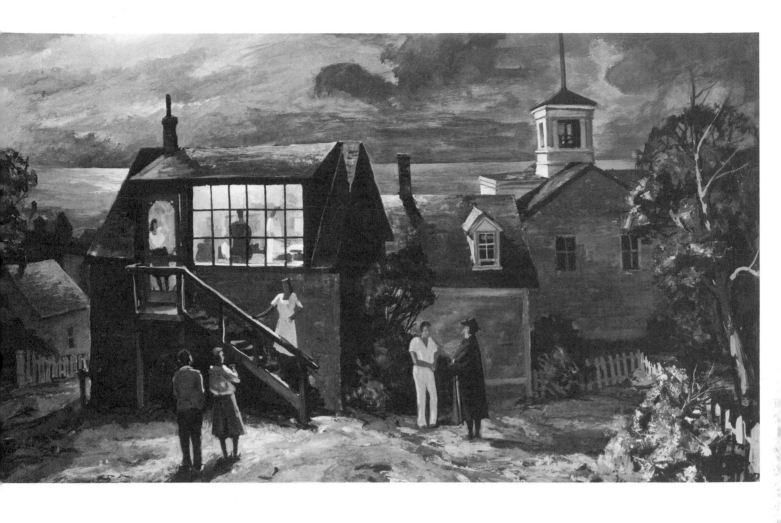

Studio Party by Carl Gaertner.

The painter has succeeded extraordinarily well in catching the quality of a moonlit night, despite the fact that this is a predominantly dark picture. It is surprising to see how little light one needs to create a luminous picture. The viewer cannot see the moon, which is merely suggested in the upper left-hand corner and suggested once again by the patch of light that appears on the steeple in the upper right. Actually, the strongest source of light is the illuminated studio window which is the focus of the painting and which casts edges of light on the figures standing outside, as well as on the ground. It is well to remember that night is not mere pitch blackness, but contains many variations and gradations of grays, with only an occasional note of real blackness. Within this range of grays, an enormous variety of tone is really possible, provided that the artist observes his subject carefully. (Photograph courtesy *American Artist*.)

51

and the second on a prepared gesso ground, the purity of which helps to accentuate the brilliancy of the color laid over it.

HOW TO PREPARE A
TEXTURED GROUND:
GESSO COATED
WITH SIZE
Diagram B, with various hues, is a demonstration of painting on a prepared gesso surface. This surface was made with thick gesso, and placed in little lumps on the canvas, thus giving a mottled appearance. When the pure gesso was quite dry, two coats of size were washed over the surface, and then the various tints seen in the reproduction were painted in a very liquid state over this prepared ground. The top tint is composed of cobalt blue; the second tint of viridian; the third tint of light chrome; the fourth tint of yellow ochre; the fifth tint of rose madder; the sixth tint of burnt sienna; and the last tint is permanent crimson mixed with a little ultramarine blue and white. Each of these seven tints was mixed with a large quantity of turpentine and a little copal varnish.

TEXTURED GROUND
FOR SPECIAL
EFFECTS
In the landscape below (D), this painting, like the picture of Rouen, had the ground specially prepared in certain places with gesso so as to get a texture appropriate to the subject to be depicted in oil color. First, the whole of the canvas was painted over with a flat coat of gesso. Then a second coat was painted over the original ground. After the two coats of gesso were completely dry, size was used to keep the surface from being too absorbent.

Gelatin makes an excellent size. It consists of purified glue, and can be purchased in thin flakes or sheets which must be dissolved in hot water, care being taken to keep the water below the boiling point. Ten sheets of gelatin to one pint of water makes a good consistency for working purposes. A large brush should be used for coating the gesso surface with liquid size. When this is dry, another coat can then be placed over it, and if necessary a third coat. Acrylic gesso does not require sizing.

The mountain subject (D) in Plate XV was delineated in outline with a lead pencil. As the original mountain had a certain amount of texture, extra gesso was used to suggest the vertical strata. The foreground at the foot of the picture was also treated in a similar way.

In beginning to paint this little picture, the reproduction of which has the same dimensions as the original, the sky was painted first behind the mountains. Then the shadow on the mountains and the outline of the mountains were painted in dull purple and blue. The foreground, with deeper tints, was painted in a solid manner. After the sky was completed, the most difficult part of the painting was attempted, i.e., the various colors seen in the texturous rock strata on the vertical formation of the mountain. Curiously enough, when the oil color was applied to the prepared gesso texture on the mountainside, several accidental possibilities arose, caused by this surface, which made the problem comparatively easy. The broken groundwork suggests a good deal of intriguing detail without losing the main effect of the picture.

GESSO USED AS MODELING MEDIUM

In Plate XVI is the first stage of *Old Houses, Rouen*. The wooden panel, after receiving two coats of gesso—which had previously been mixed with water and with copal varnish so as to make it nonabsorbent—was allowed to dry thoroughly. Only one coat of size was necessary, as the copal varnish prevented the suction of oil. The importance of nonabsorbent panels for oil painting is obvious, otherwise the oil would deeply stain the gesso, and destroy its brilliancy.

The drawing of the buildings was made with an ordinary B pencil. The color tints seen in this picture were then applied, but with a very liquid wash. They were put on in the same manner as a transparent watercolor painting, with plenty of turpentine mixed with copal varnish. The roofs were tinted with raw sienna, and the shadows were made of permanent crimson and ultramarine blue. While the paint was still wet, a little raw sienna was blended with the shadows in places.

In the second stage (Plate XVII), a portion only of the subject is shown, so that the reproduction should have exactly the same dimensions as the original painting. There is no reason why gesso should not be used as a medium for modeling various surfaces in a picture before using the oil pigment. With this thought in view, the gesso was heaped fairly thickly on certain parts of the roofs to represent their texture or character. It was also used to suggest the broken surfaces of the walls and other incidental portions of the picture. The sky, too, had a certain amount of extra gesso coating so as to get a somewhat stringent brushmark effect. When the material was completely dry (referring to the second stage only) the broken walls, towards the right-hand side of the picture, were painted very thinly with various colors, well mixed with oil medium. Also the green woodwork, seen on the face of the highest building towards the left, was painted over the gesso ground, and the yellow and orange tints were painted along the highest contours of the roofs.

Plate XVIII shows the finished *Old Houses, Rouen* painted over a gesso ground. It was done by the method used for painting on ordinary canvas. The prepared gesso ground makes an admirable surface for painting on, especially the part that has been previously modeled in suggestive relief. I do not know of any other material on which it is so easy to paint a picture and to take it to a more or less finished stage.

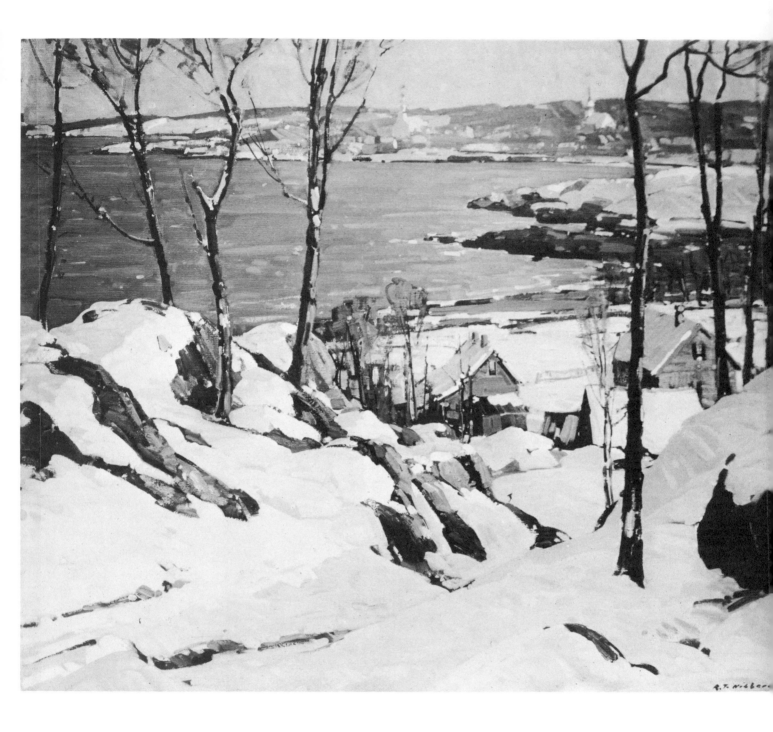

Rockport in Winter by Aldro T. Hibbard.

The complexity of a snowy landscape can often be solved if the artist sees the elements in his composition as flat shapes. The artist has simplified this potentially confusing composition by painting the snow as flat areas of light and very delicate shadow, broken by flat strokes of halftone and deep shadow where the rocks break through. The rocks and the treetrunks are very carefully placed to lead the viewer's eye down through the center of the picture to the distant house and cluster of trees, then upward across the water to the landscape beyond. The trees frame the center of interest precisely, but their forms are never rigid, always slightly angled and broken. The artist's method of painting in flat, decisive strokes is particularly apparent in the spur of land that juts out into the water, where each stroke has been placed and left—never softened or blended to detract from the feeling of firmness. (Photograph courtesy *American Artist*.)

9

GLAZING

These days, glazing is seldom used as an accessory to oil painting. It has almost fallen into disrepute, and artists are inclined to view it with grave suspicion, since they feel that glazing is too fragile for practical use. Some glazed oil paintings have undoubtedly been ruined in the process of cleaning, when the outside coat of varnish, together with the colored glaze below, has been cleaned right away from the surface of the picture. This calamity can be avoided if the liquid glaze is washed over the oil pigment as soon as it is dry enough, so as not to be disturbed by the brush. The glaze will then become part of the material underneath, while still retaining its luminous appearance.

WHY GLAZE A PAINTING?

Rightly understood, glazing—which means applying a transparent layer of liquid color over a lighter undertone—can give certain additional qualities to an oil painting which could not be achieved by any other process or method. There is nothing accidental about the technique of glazing. On the contrary, the mind must be well under control to achieve a definite and artistic result. It is not advisable to attempt to glaze any portion of a painting until the color has been previously decided on. Neither should one glaze any oil pigment without being quite certain as to the exact portion of the picture requiring a liquid wash of transparent color. It is not generally known that opaque colors, such as vermilion, Naples yellow, chrome, etc., can be used as glazes if sufficient liquid medium is used to float the pigment easily over the desired ground.

Naturally, there is no object in glazing at all unless some additional artistic purpose is served in doing so. To glaze to satisfy a mere whim does not answer the purpose of the painter. On the other hand, the richness of suggestive color effect gained by a transparent glaze—and to a certain extent the mystery of subdued forms partially submerged by the liquid color above—can sometimes raise a commonplace painting to a high artistic level.

LIQUID GLAZES

The picture entitled *A Street in Etaples, France* (Plate XIX) was undoubtedly helped, in the final stage, by a liquid glaze. In this painting, the walls of the cottage in the center and towards the left sparkle and glitter with the effect of sunlight. Yet the general tones of the sunlit portion are too light and out of keeping with the darker material around it. That being so, the light tones can either be

lowered by repainting, or a glaze can be used to get the correct tone of the crumbling walls. In this instance, a glaze was used (the result of which is seen in Plate XX). Notice how this picture demonstrates the desirability of good tone, while the glaze, after being washed over the original painting, has left its brilliancy undisturbed, with the added advantage of harmonizing every passage of broken color on the two houses.

Two separate colors were used for the glazing: middle chrome, and a little rose madder. Chrome is an opaque color, and a very large quantity of medium was necessary to liquefy it over the surface of the picture. The medium consists chiefly of turpentine, with just a few drops of copal varnish, so that the turpentine, when mixed with the varnish, could assist the glaze to remain firmly fixed to the painting below.

GLAZING PRODUCES A UNIQUE SURFACE

It is an interesting fact that a cleverly glazed picture contains such an artistic surface that it is practically impossible to get precisely the same tonality, or exactly the same surface quality, when painting in the usual orthodox solid manner, without finishing with a glaze. It is in this respect that the glaze scores over other methods of painting.

In some of Rembrandt's pictures, the glazes are beautifully manipulated. Also, if further proof is needed as to the impossibility of imitating glazed pictures without resorting to glazes, one has only to try to copy some of Rembrandt's masterpieces to quickly discover that it is not possible to get that luscious, rich, and subtle surface without glazing.

COLOR GLAZES

In Plates XXI and XXII are two reproductions showing further examples of glazing. In the first stage (Plate XXI), the shawl on the left was painted entirely flat on the actual canvas, without any suggestion of shadows. The color used for the pattern in the top part and elsewhere was ultramarine blue, mixed with white. In this picture there is no striving after excellent drawing, as the subject is used merely as a demonstration of the value of glazing.

On the right-hand side of Plate XXI, the circular formation of the material shown was painted—like the example on the left—directly onto the canvas with orange chrome and ultramarine blue, and the dark band at the foot was made by using terra verte, while orange chrome was painted on top of the wet terra verte, as seen in the rosette pattern, and permanent crimson at the lower end of the dark green band.

In the final stage (Plate XXII), there are four colors at the foot of the page. From left to right, the first color was made with black, white, and yellow ochre; the second color with ultramarine blue, permanent crimson, and white; the third color is middle chrome; and the fourth color represents orange chrome. The two colors on the left were used to glaze the shawl, and the two colors on the right were used for glazing the other material as seen above. Each of these four tints was well diluted with turpentine mixed with a little copal varnish

before glazing. Gray was used for the shawl on the left side, and light purple was used for the shadow. This color was also washed very lightly and gently over the whole of the dark blue pattern at the foot of the shawl.

For the material on the right, middle chrome acted as a glaze over the first three folds, and orange chrome was utilized for the remaining two folds on the extreme right. It is interesting to compare the results of glazing, the middle chrome causing the darker colors to become lighter, and the orange chrome making the lighter groundwork, i.e., the canvas, to become deeper in tone.

Washing chrome yellow over blue causes the latter color to assume a greenish appearance, but orange chrome washed over the same color blue scarcely makes any appreciable difference to the original tint. Chrome yellow is somewhat opaque, even when mixed with a great deal of liquid medium. The demonstration on the right proves the truth of this statement, as the orange chrome has become greatly modified in tone after being glazed with chrome yellow.

QUICK GLAZING For some forms of commercial art, where speed is to a certain extent necessary, various kinds of fabrics could be managed in a workmanlike manner by painting the pattern quite flat on a stretched canvas, without any effect whatsoever of light and shadow. This in the hands of an expert artist should not take much time. If mineral spirit is used as a medium with the original colors, the glaze could then be laid on at the end of twenty-four hours, or possibly less. It would depend on the thickness of the pigment as to how long it would take before the glaze could be used.

I trust that these remarks on glazing will not lead the student away from the point previously stated, that glazing is a means to an end, that it is an additional charm, but not always essential to the practice of oil painting.

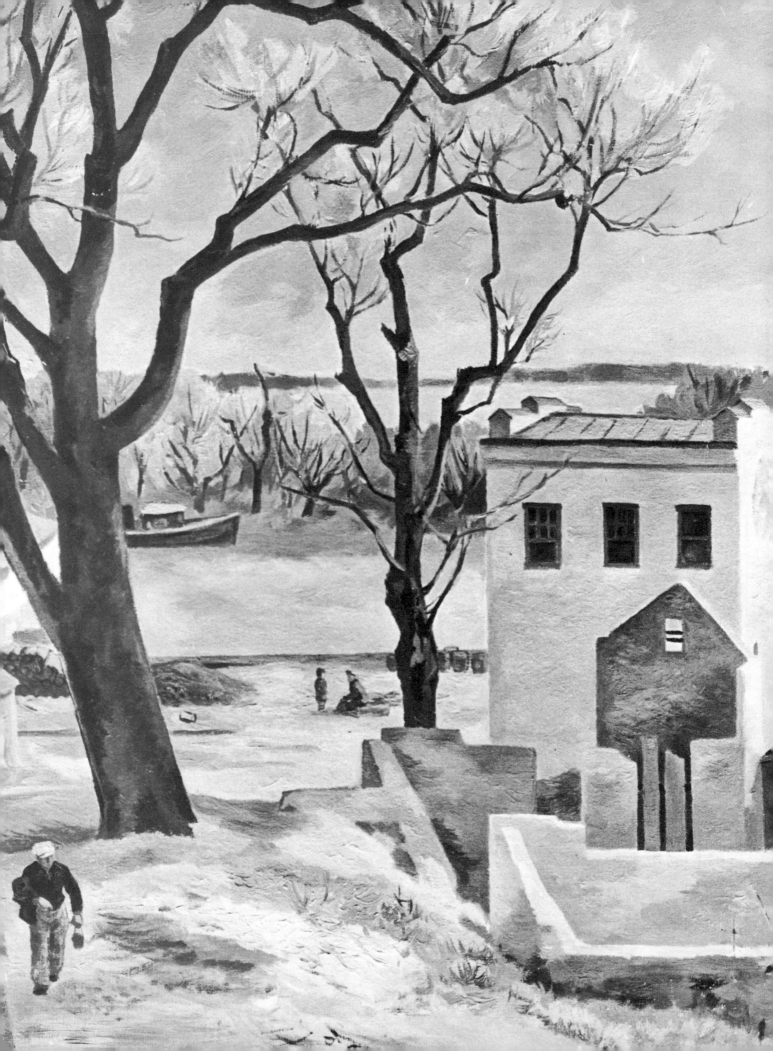

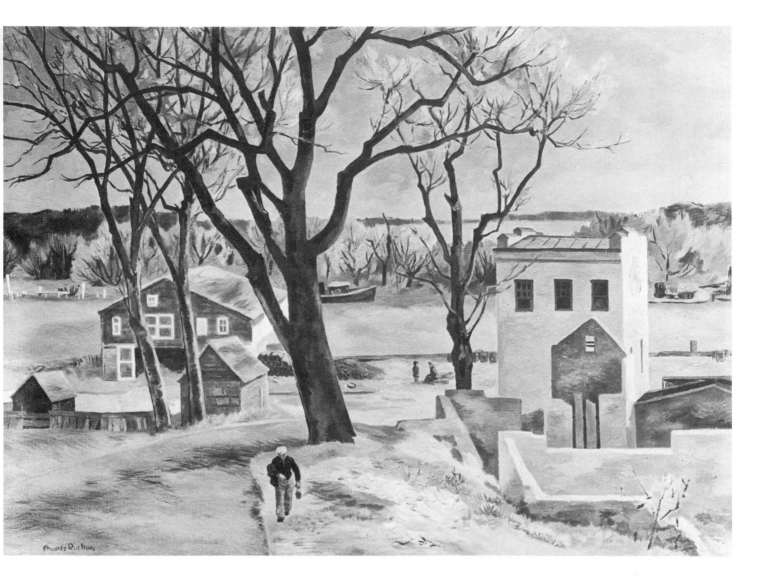

Docks at Roundout by Andree Ruellan.

Human figures, no matter how small, are often necessary to lend scale and focus to a panoramic landscape. The center of interest in this composition is the area where the winding road, the big central tree, and the walking figure all meet. The figure gives the viewer a sense of the loftiness of the trees and the depth of the landscape beyond. The artist has also made use of the very attractive interplay of the squarish, geometric forms of the architecture and the lively, irregular forms of the trees and their foliage. The painting also communicates a very clear sense of the direction of the light, which enters from the extreme right, so that only the walls on the right receive the direct light, while the walls that face us are in shadow. Notice, too, how the entire picture is painted in small strokes of broken color, which unify the diverse textures of architecture, trees, sky, and water. (Collection Pepsi-Cola Company.)

Connecticut Farm by Millard Sheets.

Studying the complex, profuse forms of the landscape, the beginning painter is inclined to forget that hills and trees have distinct shapes, with planes of light and dark which must be painted as carefully as the more obvious geometric shapes in a still life. In this lively landscape, the artist has visualized each tree, for example, as a cluster of rounded shapes which are carefully modeled as deliberately as one might paint the solid shape of a piece of fruit. The rolling shapes of the land are also painted as rounded geometric forms, grading from light to dark; several such curved shapes, individually modeled, are locked together to form the landscape, which has a strong feeling of solidity and a sense of deep space. Notice how the direction of the brushstroke seems to follow the shape—particularly in the trees and the rolling ground in the middle distance. (Photograph courtesy *American Artist.*)

10

OUTDOOR
SKETCHING

When painting in oils outdoors, a good deal of time is invariably taken up in opening the paintbox, setting up the easel, and getting the colors arranged on the palette. Judged from that standpoint, oil painting is at a disadvantage when compared with pastels or watercolor, but it is comforting to remember that with oils much speed can be obtained, without any loss of technique; also, as mentioned before, mistakes can be quickly remedied.

BEGINNING A SKETCH When commencing a sketch, some students may prefer to use mineral spirit or turpentine, since the canvas can be rapidly stained with a liberal supply of this medium. Another alternative is to paint in the manner depicted in Plates XXIII and XXIV. The subject, *The Luxembourg Gardens, Paris,* was chosen by the artist for two or three reasons. The first and predominant idea on discovering the subject, one sunny morning, was the somewhat original composition, as seen in the vase or urn placed on the pedestal, rising up dramatically against the light sky towards the left; the horizontal band of dark color noticeable in the distance, including the buildings, trees, etc.; then the very dark tree on the right which supports a lighter shrub in front. The chief charm of the subject was the sparkle of sunlight which conveyed a happy message to the painter.

While this feeling still existed, the colors were rapidly applied on a new canvas (Plate XXIII). The essential design, after a very brief preliminary suggestion was made in charcoal, was immediately painted on the clean canvas. That is to say, the dark toned distance was painted without respect for any detailed drawing; the vase and the pedestal below on the left were quickly put in— mostly with burnt sienna and purple; then the dark tree on the right, using dark purple and dark gray. The value to the student of this reproduction is the speedy method employed to suggest, within twenty to twenty-five minutes, the whole scheme of the sketch. It would have been fatal to have started painting with a view to correct tones, or even to have painted the sky before the character of the subject was placed on the canvas in color.

SURFACE The canvas used was of fairly strong grain. It was very useful for suggesting broken surfaces. Looking at the reproduction, it will be seen that the canvas appears in many places irrespective of the sky, particularly on the surface of the

pedestal and in the shadows on the ground, as well as the trees on the right.

This broken surface was obtained by dragging the brush (which was almost free from pigment, and entirely free from any liquid medium) over the canvas. A student who is not accustomed to painting in the dry, dragging method, should practice until this kind of surface can be obtained with ease. Afterwards, it is delightful to work into the broken, dry groundwork of suggestive paint.

WATERCOLOR TECHNIQUES IN OIL SKETCHING

In some parts of the picture, a certain amount of pigment, mixed with turpentine and a little copal varnish medium, was used in a watercolor manner. This can be clearly seen in the reproduction in the large vase placed on the left-hand pedestal, in the cobalt blue tower in the distance, and to a certain extent in the dark tree. In the foreground, various colors were used, such as rose madder, mixed with white; yellow ochre mixed with white; gray, made with black, yellow ochre, and white; and so on. This stage of the subject completely expresses the keynote of the picture. Anything else which is painted into, or on, this surface should not detract from the design, but merely add to the natural atmosphere of the subject.

Going on to Plate XXIV, we get the completion of the sketch, but not the picture. The sketch is, frankly, true to the term *sketch*. There is a certain breeziness or outdoor look in the completed sketch, which is extremely difficult to retain in a finished picture. Finished paintings sometimes show a certain amount of selfconsciousness, or human effort. The spontaneity of a sketch is often superior to the undoubted skill displayed in the finished picture.

COPY TO STRENGTHEN TECHNIQUE

The inexperienced student is advised to copy these two stages of the sketch (illustrated in Plates XXIII and XXIV). In the first stage, the flat distance was broken towards the left by vertical brushmarks of a greenish gray tint on the blue ground. This is the foundation or the suggestion of foliage in the distance.

In beginning the finished sketch, the first item is to paint in the whole of the sky, and then it should interest students to discover that what originally looked like a dark tone across the picture in the distance, now appears to be considerably lighter, since after the sky was finished the canvas behind or above has become lower in tone, thus affording less contrast between the sky and the distance. The same remarks apply to the dark tree on the right. Liquid grays were introduced into the masonry of the balustrades, the various vases, and the shadow on the ground. Other colors were applied. This sketch should explain itself as to what colors were used.

A FINISHED SKETCH IS NOT A FINISHED PICTURE

In Plate XXV, the painting *The Luxembourg Gardens, Paris* can be described as a finished picture. A finished sketch must not be confused with a finished picture. There is a vast difference between the two. In this instance, the picture was painted in the quiet and freedom of a studio, with the help of outdoor pencil

Where the Trade Winds Blow
by Stanley Woodward.

There are always interesting pictorial possibilities where
land and sea meet. Here the foliage of the tropical land-
scape frames a breaking wave, whose jagged shape con-
trasts nicely with the rhythmic forms of the trunks and
palm fronds. Observe how the brushstrokes follow the
forms. The waves are painted in curving strokes that
interpret the movement of the water, while the foam is
painted in diagonal strokes that suggest the sudden force
of the breaking wave. In the same way, the palm leaves
are painted with long, rhythmic strokes. Because the
center of interest is the sea and the breaking wave, this is
where the light falls, while the trees and foreground fo-
liage are in darkness, emphasizing the light-struck center
of interest. (Photograph courtesy *American Artist*.)

notes and color sketches. An artist is severely tested as to how much he or she really knows when attempting to portray a complete picture. To learn the art of simplifying a detailed subject, without sacrificing good drawing and values, is a problem that has to be faced.

The finished picture of *The Luxembourg Gardens, Paris* has the appearance of solidity, which is noticeable in the pedestals and vases resting above, while the roofs of the distant buildings crowned by the tower are massed into convincing silhouette form. When it is compared with the finished sketch, students will see that the trees or shrubs on the right are deeper in tone, and that more skill is displayed in the drawing of the branches. The nearer figures received considerable attention, with additional figures in the distance—all helping to give more vitality and color contrast to the painting.

WARM, BRIGHT GROUND

There are two more demonstrations in Plate XXVI and Plate XXVII, relating to outdoor sketching. The first stage represents the ground color of the mountain subject. This time, instead of painting so directly as shown in Plate XXIII, various bright colors were originally mixed with mineral spirit and then washed over the canvas in a similar manner to transparent watercolor painting. The color of the sky was chiefly permanent crimson mixed with a little white; yellow ochre, and deep chrome. The bright range of mountains (not the dark blue mountains on the left) were painted with vivid colors, bright purples, bright burnt sienna mixed with deep chrome, and yellow ochre. As regards the blue mountain on the left with the blue line across the picture, the color here was deep crimson and ultramarine blue. The other portions of the picture were painted in similar colors, with the exception of the trees in the foreground, where burnt sienna was mixed with a little black.

After the completion of this stained color painting, a clean rag soaked in mineral spirit was used, and a certain variation of light and shadow obtained by wiping out in the same way as advocated in Chapter Seven.

PAINTING OVER A WARM-TINTED GROUND

The finished sketch of *The Canadian Rockies* (Plate XXVII) demonstrates the possibilities of using colors similar to those seen in nature, and painting them on top of a prepared colored ground like the example in Plate XXVI. Notice how, in the final sketch, the red tints of the previous painting appear in places at the foot of the picture; also red and orange, etc., expose their presence under the top layer of paint in other portions of the canvas.

This type of sketch should be done in one sitting, so as to retain the first vivid impression of the subject. Students will discover that painting cool grays, greens, and blues over a warm tinted ground enhances the power and tones of these colors. The same colors, painted directly on a primed white canvas, lose much of their intensity.

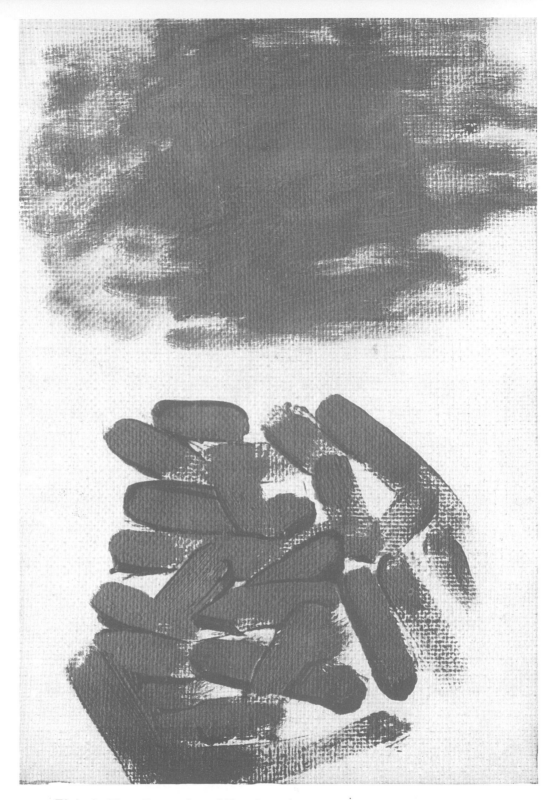

Plate I. Two Examples of Brushwork.

The upper example shows a lack of technique; the lower example shows the decision of brush handling so necessary to the potential painter in oil colors. The top example, which looks rubbed in and woolly, is precisely the opposite in effect to the vigorous handling below. No progress in technique can be made until the lower demonstration has been thoroughly mastered. A bristle brush about 1/4″ wide was used. It was allowed to function in a natural manner by flexing the brush with sufficient strength across the surface of the canvas, so that the result is clearly defined, as seen in the series of brushmarks intersecting at various angles.

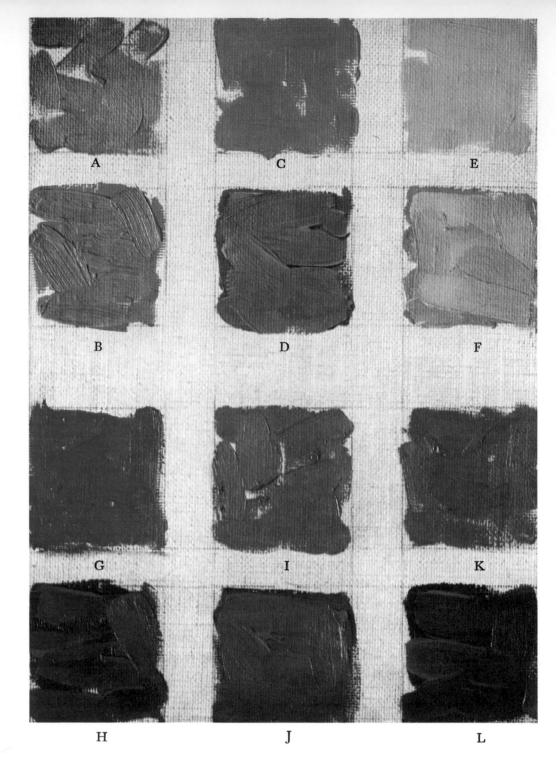

A	C	E
B	D	F
G	I	K
H	J	L

Plate II. Twelve Color Demonstrations.

In each of these twelve color demonstrations, the same decisive brush handling was used as that shown in the lower example of Plate I. Special attention should be given to the first line of colors (A, C, and E) and the third line (G, I, and K) so as to notice the changing effect of each of these colors after being painted into a wet oil paint ground as seen in the second line (B, D, and F) and the fourth line (H, J, and I). When two opposing wet colors mingle together, each modifies in a marked degree the pure tint of the other. This is evident in the result obtained by painting the orange chrome (C) into the pure cobalt ground (D). Yellow ochre (A) is improved in color when painted into the wet orange chrome (B). A full description is given in Chapter Two.

A

C

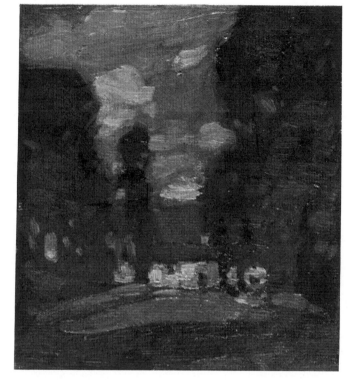

E

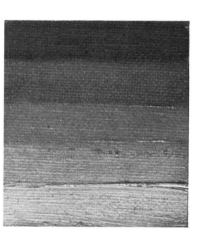

B

D

Plate III. Gradated Colors (Example 1).

Oil painting is very sensitive to subtle changes in tone. Several tones can be obtained by painting a light color into a wet, dark colored ground. For instance, yellow ochre mixed with white (A) shows four distinct tones after being painted into the dark gray ground color in example B. The whole of the three surfaces of B, E, and D were in the first instance painted quite flat, with dark purple-gray. This dark gray, which represents the deepest tone or color in Plate III, is easily recognizable in the two top horizontal bands of color in diagrams B and D, in the trees, and in the shadow across the foreground in the pictorial landscape. To make a painting similar to diagrams B and D, it is necessary in each instance to use four clean oil paint-brushes about ¼″ wide, so that each horizontal band of color can be tackled with a clean brush charged with the yellow tint A. The top horizontal band is left undisturbed so as to form a separate tint. A detailed description is given in Chapter Three.

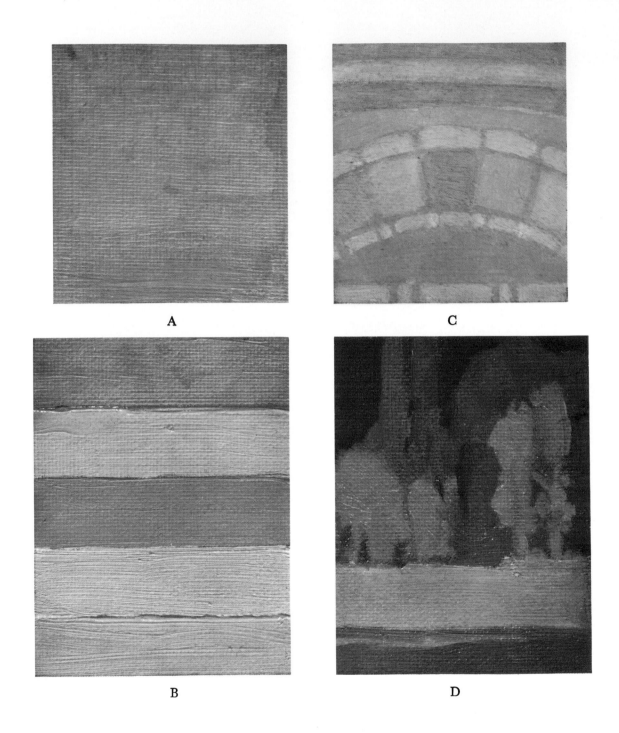

A

C

B

D

Plate IV. Gradated Colors (Example 2).

The two demonstrations of gradated color (C and D), were both prepared with a flat coat of gray of exactly the same color as seen in example A. The various tints shown in example B were then painted into the wet gray ground in demonstration C. Each of these five colors is affected by the refining influence of the neutralizing gray pigment, and a general impression of pleasant color harmony is thereby created. Demonstration D is an example of rich colors painted into the same wet gray colored ground. The method is explained in Chapter Three.

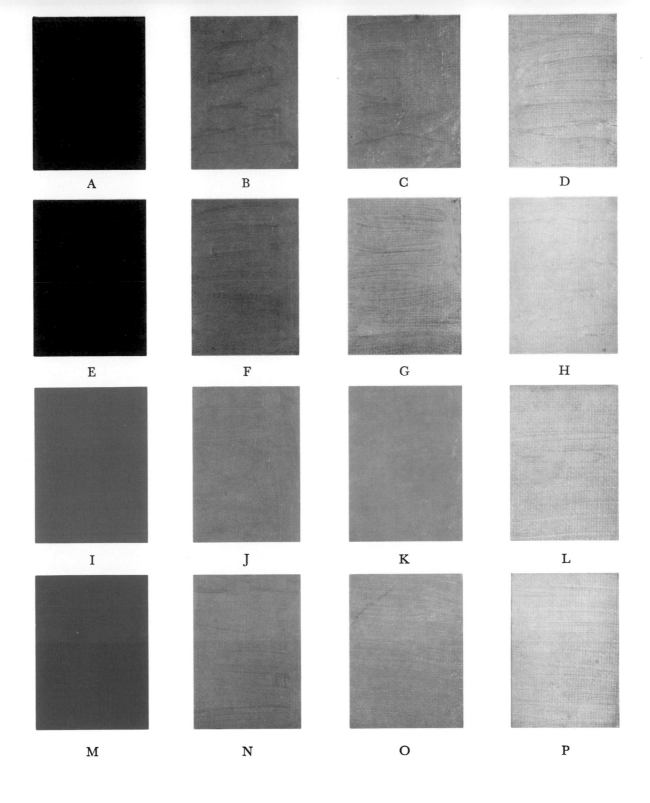

Plate V. Series of Harmonious Colors Caused by Mixture of Ivory Black in Gradated Tints.

On looking at this page of color examples, the student will notice that every tint is free from garishness or crudity, and that the last four tints on the extreme right-hand side (looking vertically downwards) are ultra-refined and delicate in tone. Each of the four colors, A, E, I, and M, shows the original tint, from which, by the mixture of white, and occasionally white and yellow ochre, all the tints (spreading horizontally across) were evolved. Detailed description is given in Chapter Four.

Plate VI. Demonstration of Good Color Tone.

A striking but simple demonstration of good color tone, obtained by the use of two colors only—gray and orange chrome. The example marked B, which is warmer in color than D, is the result of painting orange chrome over a wet gray ground. The gray used (a mixture of ivory black and white) is seen in example A. The opposite treatment was adopted to obtain the tint in D by painting a coat of orange chrome, and then covering this surface with gray. The method is described in Chapter Four.

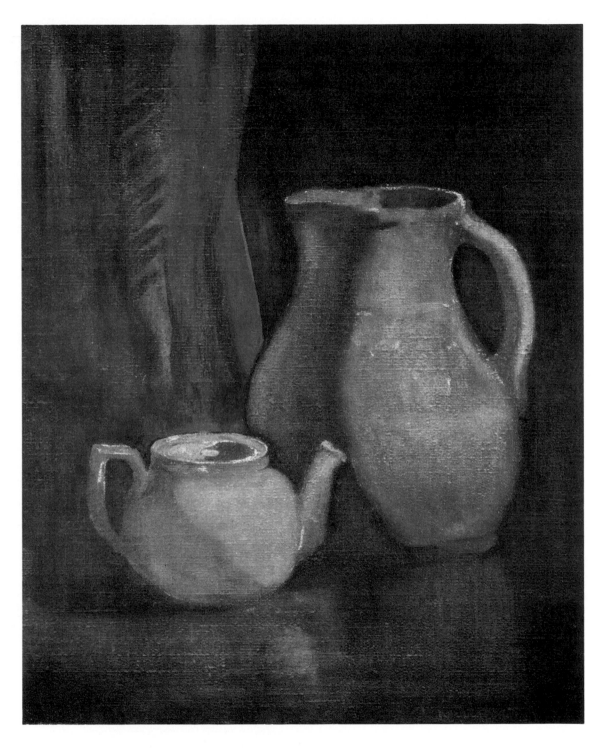

Plate VII. Still Life (First Stage).

For this still life group, a preliminary outline was made in charcoal on the canvas. The charcoal was left unfixed, since this crumbling material mixes excellently with liquid oil wash. In this first stage, all the colors employed were generously diluted with quick-drying mineral spirit. For the dark background, the oil color was laid on a little more solidly than for the foreground objects. This method of washing in deep color tones not only saves a good deal of time, but makes an excellent foundation on which lighter colors can be painted. Full information in Chapter Five.

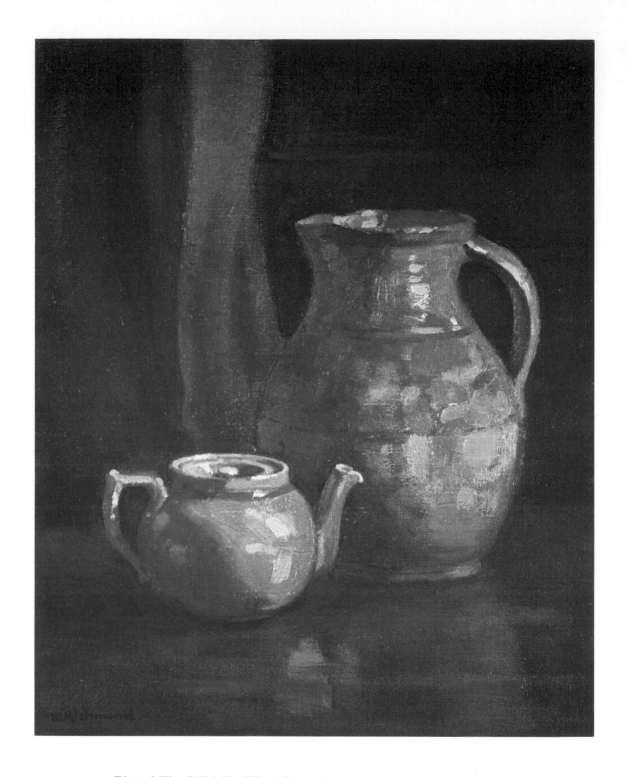

Plate VIII. Still Life (Final Stage).

The final stage of this still life was completed in one sitting, on the liquid ground wash shown in Plate VII. Oil pigment proved an excellent medium for rendering the textural surface of the pitcher. The halftone and highlights on the rose tinted teapot received some fairly thick paint, but the shadows on the teapot and pitcher were purposely kept in a more transparent state so as to retain a feeling of reality. The method is fully described in Chapter Five.

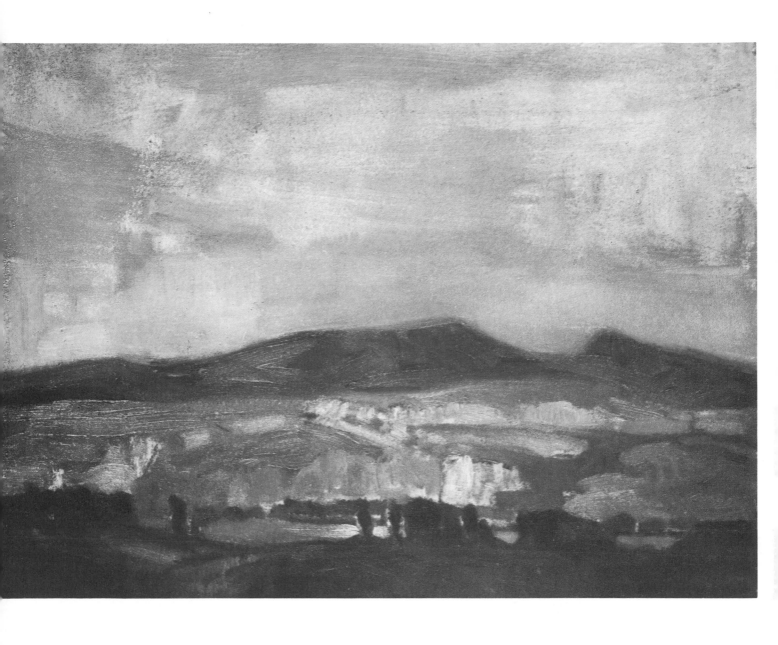

Plate IX. Near Le Puy, France (First Stage).

This represents a preliminary landscape sketch on ordinary cardboard, which had previously been primed with a mixture consisting of whiting, gelatin, sand, and hot water. (One can also use acrylic gesso and sand.) Notice the warm yellows and browns used in the first stage, particularly in the sky and middle distance. They make a very good foundation for painting in cool colors while the first coat of oil color is still wet. Full information is given in Chapter Six.

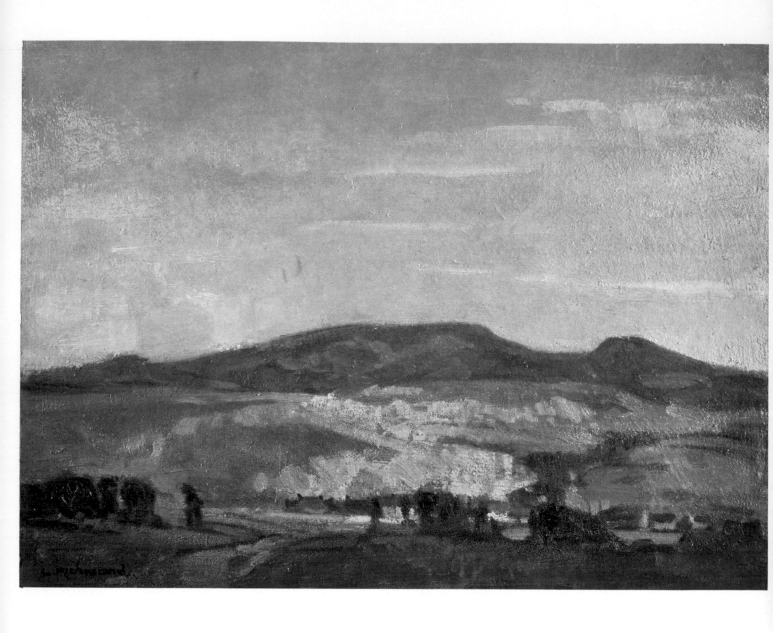

Plate X. Near Le Puy, France (Final Stage).

The warm colors used in the first stage proved invaluable during the completion of this sketch. The pale blue of the sky assumes luminous qualities when painted into the wet yellowish ground. The same pale blue painted directly on a surface unprepared with warm tints would not only lack solidity, but would also lose the feeling of radiating light. In other words, since the blue sky in nature is influenced by the source of light, i.e., the sun, all landscape sketches which deal with the sky should echo the effect of sunlit warmth. The oil paintbrush, when charged with pigment, clings very pleasantly to the prepared sand surface of the board. This granulated effect, for sketching purposes, gives a fascinating oil pigment surface combined with a certain suggestion of vibration. A detailed description is given in Chapter Six.

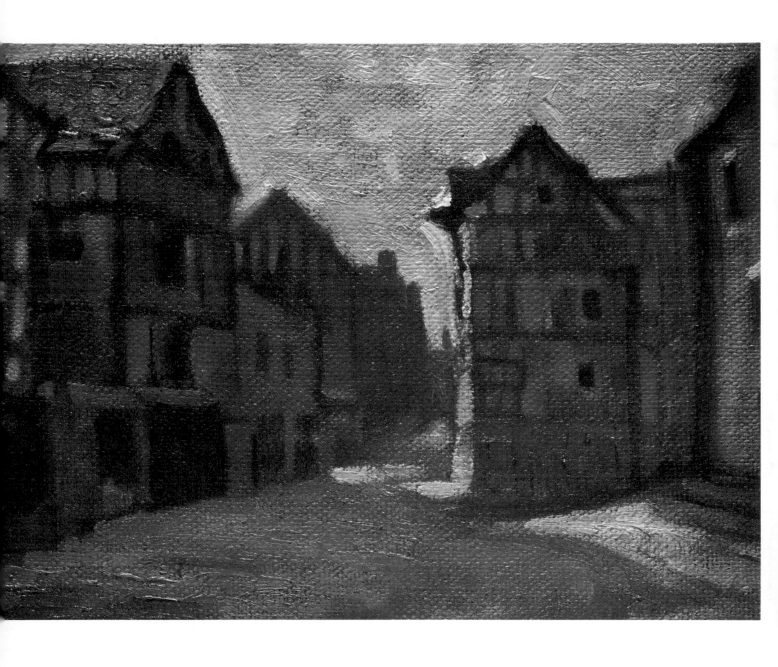

Plate XI. A Street in Rouen, France (First Stage).

An example of sketching on ordinary, brown colored buckram. The coarseness of the material is no drawback for the practice of oil painting. On the contrary, it is a healthy tonic, especially if the artist wishes to record a passing effect of nature in which meticulous detail is of no importance. To the student whose oil paintings are lacking in textural vigor, a series of sketches made on this robust material is much to be recommended. The method is described in Chapter Six.

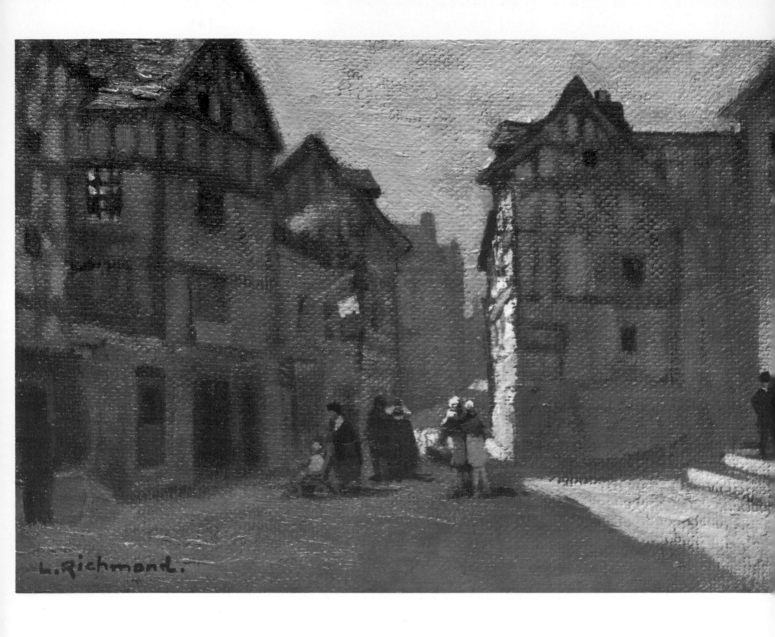

Plate XII. A Street in Rouen, France (Final Stage).

To complete the sketch begun in Plate XI, a considerable number of grays were brought into use, thus helping to suggest the outdoor atmosphere so essential for this type of subject. The cool grays also help to render the tones more accurately. This is very noticeable in the gable roof building towards the right and in the roadway in the foreground. The sky is less assertive and more refined in tone. Figures were added to help the general pattern of the sketch and also as an important item in tone contrasts. See Chapter Six for full description.

A

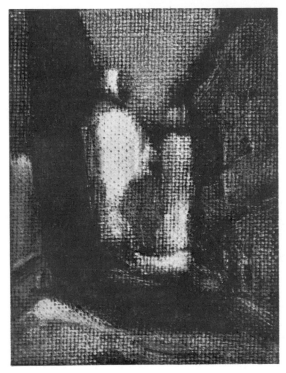

B

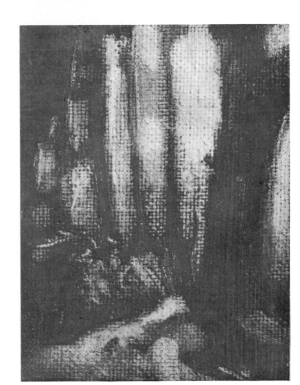

C

Plate XIII. Two Examples of Wiping Out.

In wiping out, there is no limit to pictorial invention. As regards the method involved, there is no profound secret to disclose; yet very few artists appear to use, or even to have heard of, the advantages accruing from experiments in this adventurous way of exploiting oil colors. All that is necessary is a canvas, or some other appropriate surface, over which should be painted, as flat as possible, some desirable dark color. Then, by using a clean linen rag dipped in turpentine, or petroleum (rectified), all manner of results can be obtained by rubbing, or wiping out, the dark paint with the rag. Each touch of the rag will lift a corresponding amount of oil pigment, always with delightfully soft edges. A gives the original colors before wiping out. B and C convey suggestive pictorial matter. Method in Chapter Seven.

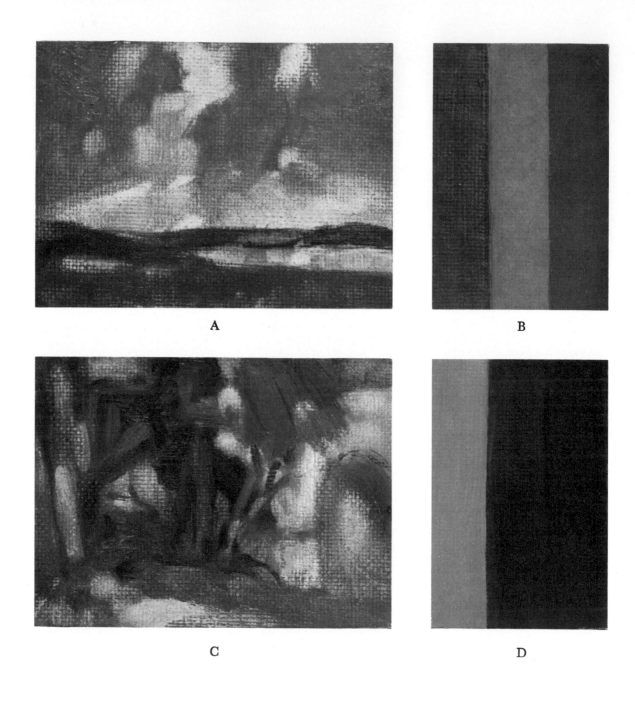

A

B

C

D

Plate XIV. Further Examples of Wiping Out.

Two landscapes (A and C) done solely in the wiping out method. Greater care than usual had to be exercised in doing these two demonstrations, since each sketch was evolved with the aid of three ground colors (B and D). A careful study of these two examples together with the information given in Chapter Seven will enable the student to grasp the essentials of wiping out methods when more than one color is involved.

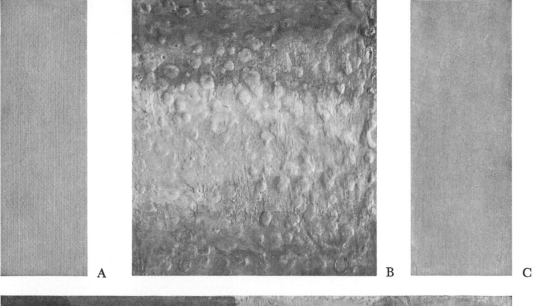

A B C

D

Plate XV. Painting Over Prepared Gesso Ground.

The two narrow panels on the top line are both painted with middle chrome: the example on the left (A) was painted directly onto the primed canvas; the example on the right (C) was painted over a prepared gesso ground. The purity of the gesso underneath helped to retain the full richness of the original color, the example on the left is cooler and slightly tinted with green, owing to the lack of color purity in an ordinary primed canvas. The top center demonstration (B) was originally prepared with a series of gesso touches or spots. After it was dry, liquid oil paint of various colors was washed over the surface. The mountain picture (D) received a preparation of gesso before painting was begun. Notice the suggestion of broken surfaces in the sunlit portion of the mountain. The preparatory gesso ground is entirely responsible for this interesting surface. The gesso ground in each demonstration was made nonabsorbent by washing it over with two coats of pure gelatin size. Method in Chapter Eight.

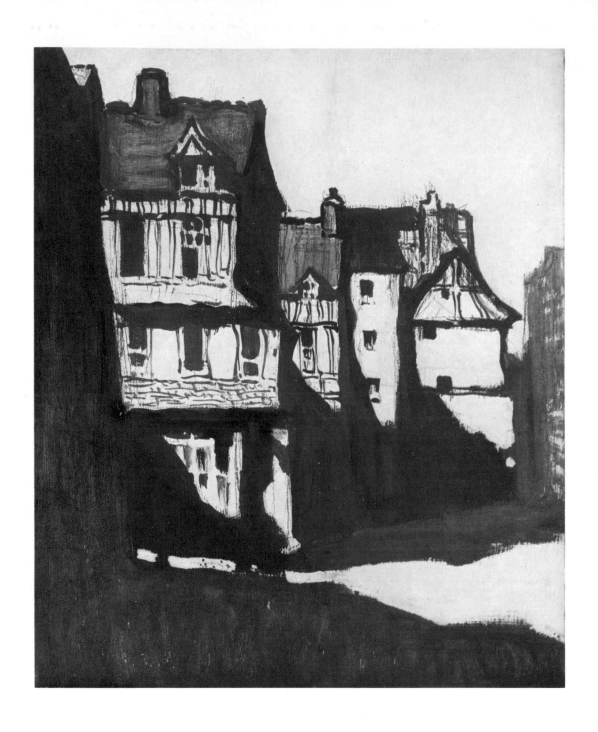

Plate XVI. Old Houses, Rouen (First Stage).

An example of painting on a wooden panel, which has previously been well coated with gesso mixed with copal varnish—so as to obtain a nonabsorbent surface. The subject was drawn in pencil, then outlined with a purple-brown tint with a small, pointed, sable brush. Some of the same color was also used for massing in the main shadows. While the shadow color was still wet, a little raw sienna was allowed to float into the purple tints. The roofs at the top of the picture received a very thin coating of raw sienna, more for the purpose of indicating their solidity than as a painting effect.

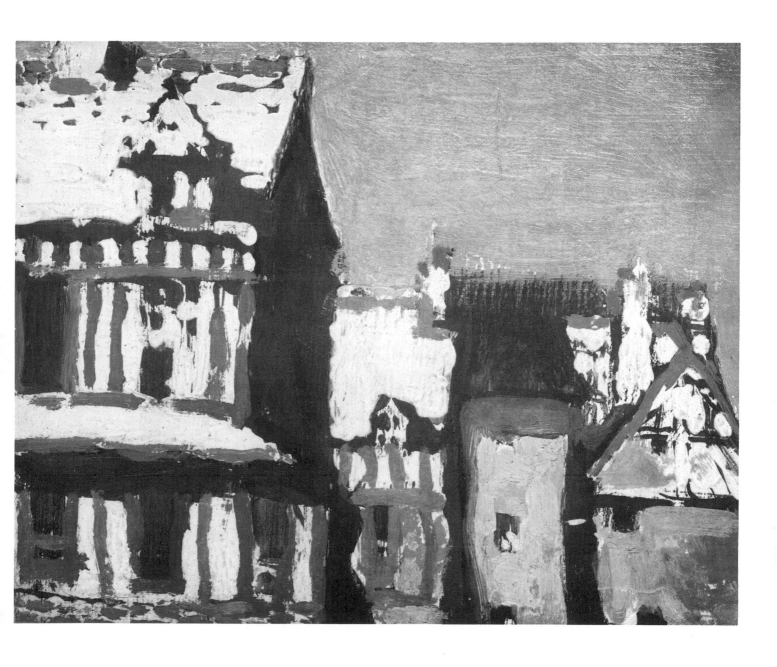

Plate XVII. Old Houses, Rouen (Second Stage).

A section of the second stage of the gesso panel painting begun in Plate XVI was selected so that the reproduction could be made the same size as the original picture. Liquid gesso, mixed with copal varnish, was heaped on the rooftops (hiding most of the preliminary wash of raw sienna) and also applied to the front walls of the various buildings. Notice the pronounced texture of the gesso and how suggestive color becomes when painted over the broken gesso ground. This can be clearly seen in the lower walls on the right at the foot of the reproduction.

Plate XVIII. Old Houses, Rouen (Final Stage).

Here is the finished picture, *Old Houses, Rouen,* painted on a pronounced gesso ground. The colors are now more sober in tone and more in keeping with the antiquity of the subject. Yet, with the aid of the purity of the gesso below, the colors above will retain their correct tonality for a long period. The painters in early times understood the value of gesso as a help in retaining the brilliancy of oil pigment. It is important to make the gesso nonabsorbent, otherwise it will be stained with conflicting tints, and destroy any reason for using it. For permanency, a thin layer of absorbent gesso can be placed on a nonabsorbent ground. Details in Chapter Eight.

Plate XIX. A Street in Etaples, France (First Stage).

This painting looks empty, or devoid of rich color tone. In other words, although the cottages on the left side are fairly sunny in character, yet it presents a somewhat chalky effect. Since the oil pigment was handled with a certain amount of decisive freedom it would not be of much advantage to repaint the subject if another method could be adopted to answer the same purpose. Glazing was therefore used.

Plate XX. A Street in Etaples, France (Final Stage).

By comparing this with Plate XIX, it can readily be seen how much more artistic a painting can be made by judicious glazing. The difference is all the more interesting because of the ease and rapidity with which a liquid color can be made to float over the oil paint surface. The appropriate time for glazing is when the ground colors are still wet, but dry enough to float liquid color so that the painting underneath is left undisturbed. The method is fully described in Chapter Nine.

Plate XXI. Two Examples Showing Direction of Folds in Cloth (Colored Fabrics, First Stage).

This material was painted in a direct manner, irrespective of light and shadow. Since both these examples were painted with the knowledge that they were to be completed by means of shadow glazing (Plate XXII), the utmost simplicity of statement was aimed for, as glazing invariably softens and subdues the clearest shapes expressed in color massing.

Plate XXII. Two Examples of Shadow Glazing (Colored Fabrics, Final Stage).

The first two rectangular colors commencing from the left at the foot of the reproduction were used for glazing the design on the left: the warm gray for the lighter portion of the material, and the purple for the shadow on the right-hand side of the same material. The other two rectangular colors below were used for the fabric on the right: the chrome yellow for the left portion and the orange chrome for the two hanging folds on the right. Each of the four colors chosen were well diluted with running turpentine mixed with a slight amount of copal varnish. The copal varnish helps the glaze to adhere to the canvas. The method is described in Chapter Nine.

Plate XXIII. The Luxembourg Gardens, Paris (First Stage, Sketch).

In this preparatory sketch, the method illustrated not only saves time in outdoor sketching, but also gives great assistance to the artist when laying on the final colors. A cursory outline was made in charcoal and followed immediately by an outline in dark purple of the leading objects in the foreground. The distance was outlined in dark blue and then massed in with the same color blue. Other colors, such as burnt sienna, sage green, purple, etc., were dragged about the foreground area, but not too solidly, so that the canvas could be seen in most places. The method is described in Chapter Ten.

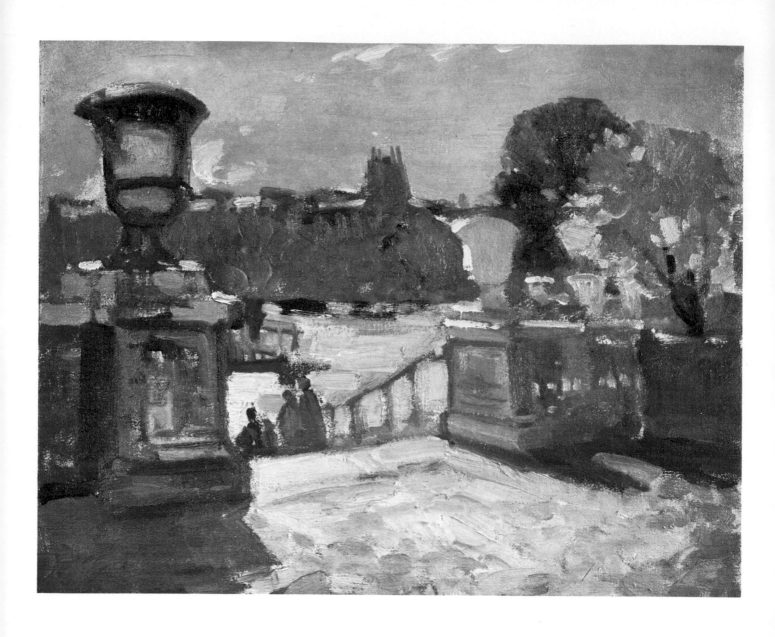

Plate XXIV. The Luxembourg Gardens, Paris (Second Stage, Finished Sketch).

The dark colors and partially exposed canvas in the first stage made an excellent background into which the lighter colors of this final stage of the sketch merged admirably. This plate demonstrates the use of painting light colors on a dark oil paint ground while still wet. Various grays, yellows, and green were involved in this sketch. The sky helped to complete the outdoor effect so necessary if the sketch is to reach any standard of success. Full information is in Chapter Ten.

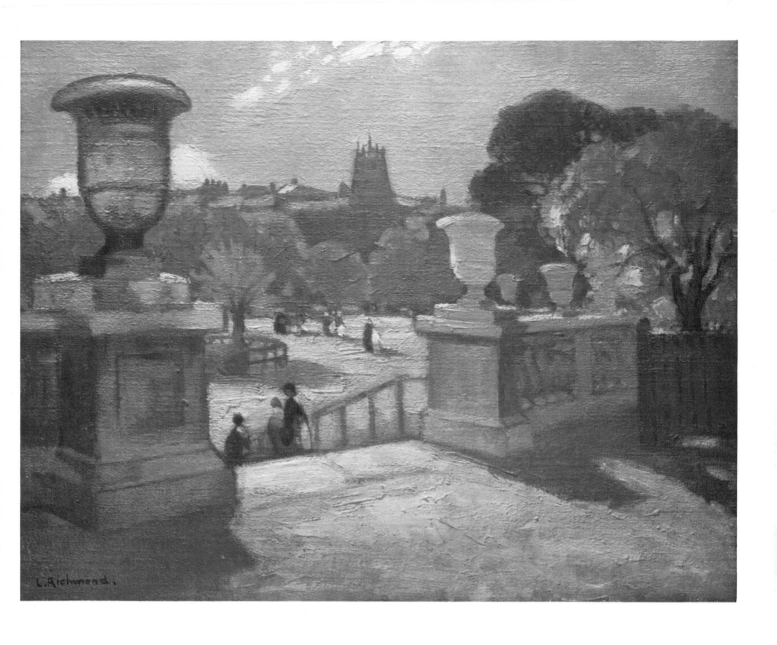

Plate XXV. The Luxembourg Gardens, Paris (Final Stage).

For the finished picture painted indoors from sketches and pencil drawings, the same method of blocking in dark color masses as seen in Plate XXIII, followed by the more subtle grays, yellows, etc., can be adopted. Care must be taken not to paint on top of a partially dry ground or else cracks will invariably follow. The first and second stages can be done in one sitting with the oil pigment in a healthy, wet condition. Some three weeks should elapse before commencing the final painting. Full description is given in Chapter Ten.

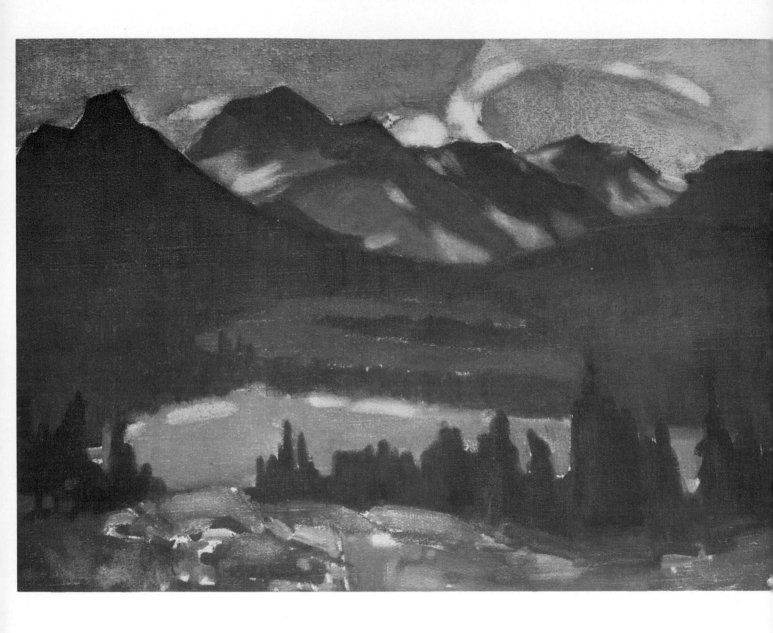

Plate XXVI. The Canadian Rockies (First Stage, Sketch).

All the colors in the first stage of *The Canadian Rockies* were laid on the canvas with liquid color washes—precisely in the same manner as transparent watercolor painting. Quick-drying mineral spirit was the medium for this purpose. Wiping out proved very useful at this stage, evidence of which can be seen in the lighter clouds of the sky and the patches of snow in the farther mountains. The stones or rocks in the foreground were also slightly wiped out with a rag steeped in turpentine. The method is described in Chapter Ten.

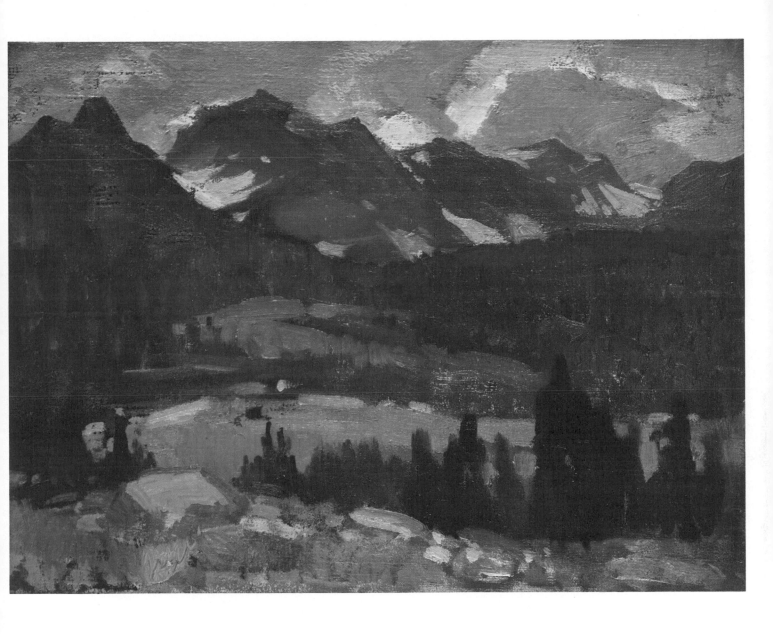

Plate XXVII. The Canadian Rockies (Finished Sketch).

It is comparatively easy to finish a sketch when all the canvas has been covered with a series of bright warm colors, yet dark enough in tone to assist the final painting. Evidence of the first stage can be seen in many places in this sketch. The harmony of the brilliant ground tints keeps the opposing colors on top from being too assertive. The blue mountain rising upward on the left, which displays touches of dark red through the blue pigment, causes the blue to tone well with the adjoining reddish brown mountain. Similar liaisons between contrasting colors occur in other portions of the sketch. A full description is found in Chapter Ten.

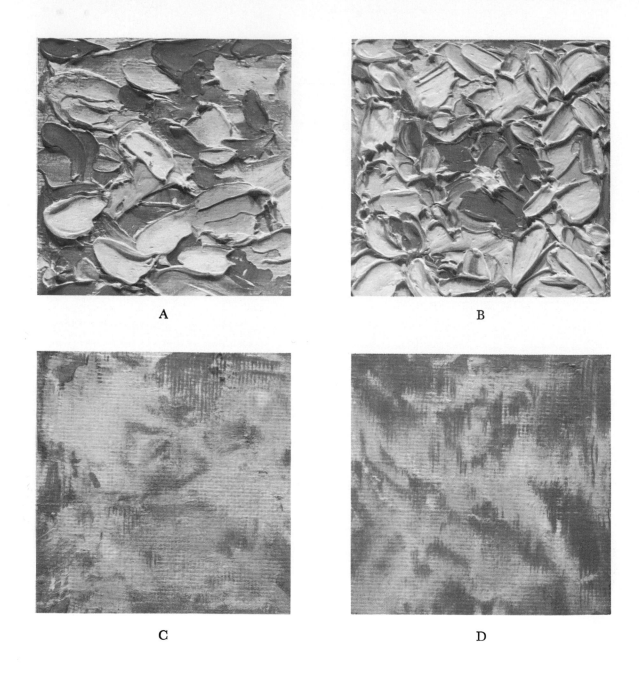

A

B

C

D

Plate XXVIII. Four Examples of Palette Knife Painting.

These four colored squares are the same size as the original paintings. The two examples on the top (A and B) adequately convey the effect of palette knife painting. In each instance, the dark tints were laid on first, followed in more solid form by the light colors. The thick ridges of paint so clearly noticeable were caused by the flat pressure of the flexible palette knife squeezing the color upwards along its edges. The two lower examples (C and D) show the effect of scraping off the thick oil pigment from the corresponding examples above. Method in Chapter Eleven.

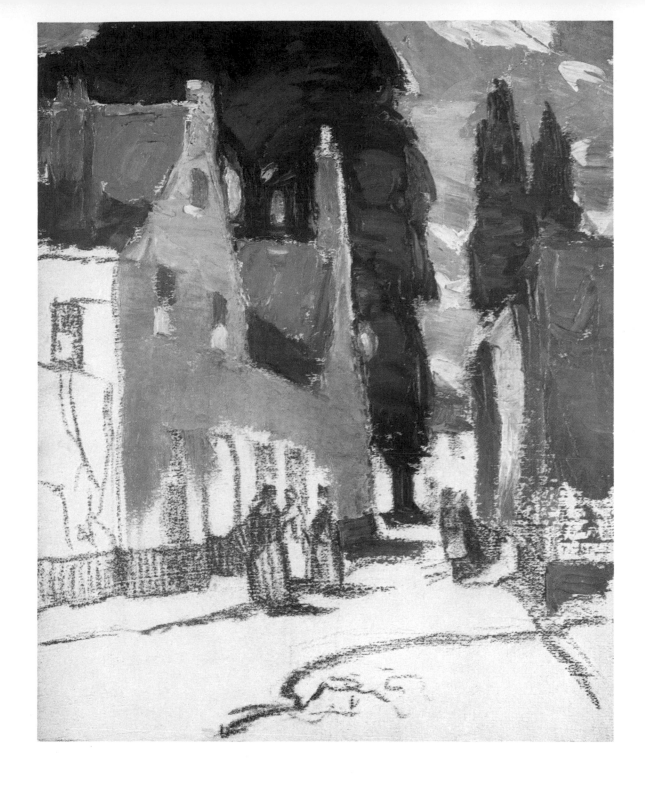

Plate XXIX. A Scene in Bruges, Belgium (First Stage).

A demonstration of palette knife painting directly on the canvas. A strong outline was made in charcoal, combined with a certain amount of mass shading. The drawing was sprayed with fixative before any color was laid on. From a technical standpoint, it is important that the marks of the palette knife should be easily recognized by the manner in which the oil pigment has been handled. Any similarity to brush handling is undesirable, as the steel palette knife treatment cannot be successfully imitated by using any other tool or a brush. Description in Chapter Eleven.

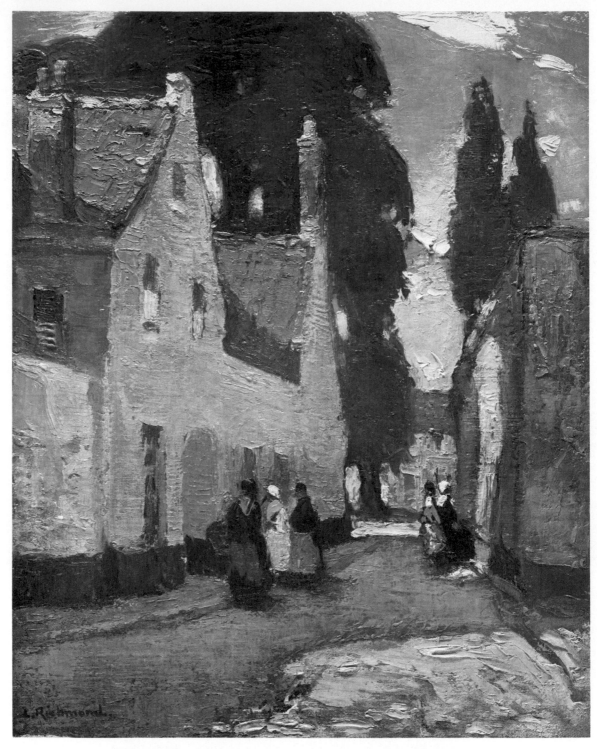

Plate XXX. A Scene in Bruges, Belgium (Final Stage).

It took a certain amount of time to finish this painting because of the suggested detail. In this final stage, the end (or pointed part) of the palette knife was brought into use, especially for windows, the tops of chimneys, the outline of trees, etc. The trowel-like surface of the knife is admirable for flattening out several colors already on the canvas—in the shadow portions of the picture—and reducing them to a state of correct tonality.

Plate XXXI. Woodland Scene Painted with Palette Knife.

The little landscapes in this plate and the following one prove the possibilities of suggesting serious pictures to the artist. The broad effect of palette knife work demands decisive painting. This is all to the good when creative efforts are being made. See Chapter Eleven for details.

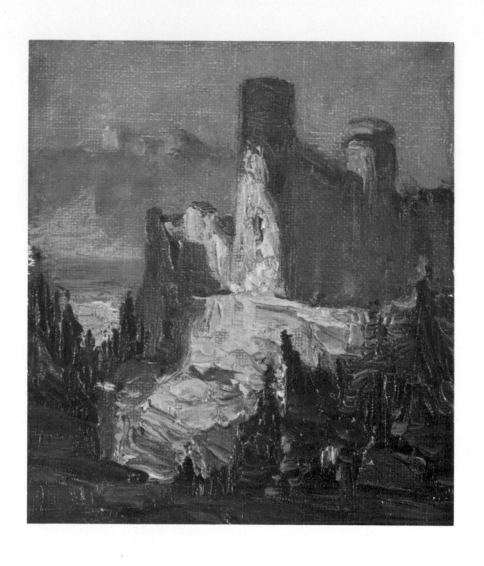

Plate XXXII. Moonlit Castle Painted with Palette Knife.

Purity and transparency of color are easily obtained when the oil pigment is squeezed flat on a canvas, whereas lack of care in handling the paintbrush is liable to cause a heavy opaqueness in various oil colors. The method is described in Chapter Eleven.

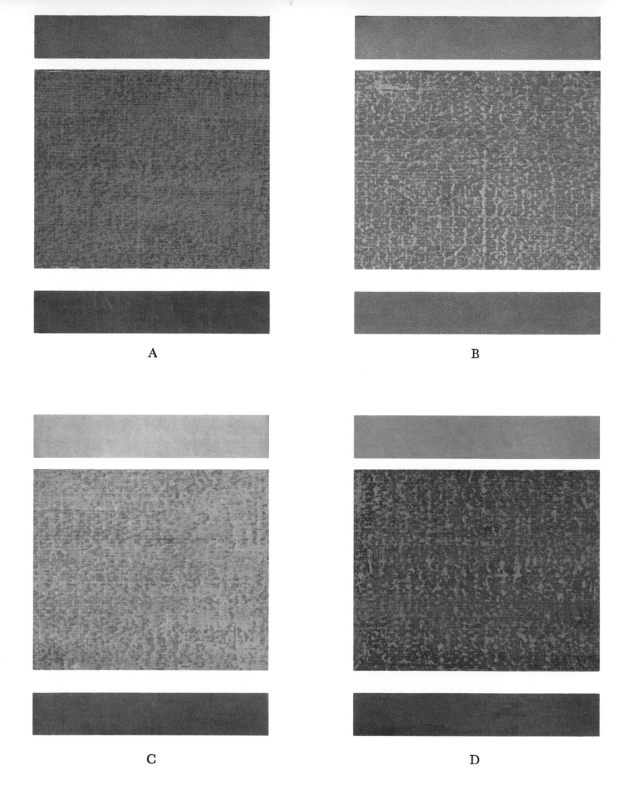

A

B

C

D

Plate XXXIII. Four Demonstrations of Scumbling.

These four color demonstrations show the effect of scumbling (dragging a comparatively dry oil pigment over a dark tinted ground). The four narrow bands of darker color (below the examples) represent the exact ground colors, and the four bands of lighter color (above the examples) represent the colors used for scumbling over the ground stains illustrated in A, B, C, and D. The method is fully explained in Chapter Twelve.

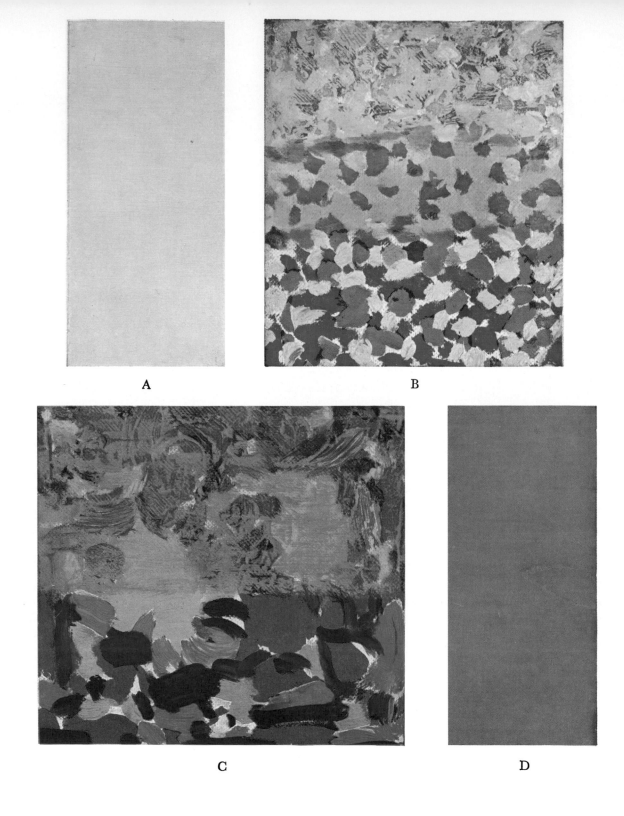

A B

C D

Plate XXXIV. Two Examples of Scumbling Over Painted Designs.

The two larger surfaces, B and C, were only partly scumbled over—leaving evidence of the original pattern in the lower end of each example. A rag dipped in rectified petroleum and rubbed horizontally across about the center produced the more transparent appearance in that section of example B. Notice how this caused the crimson color to disappear without absorbing the blue paint. Details in Chapter Twelve.

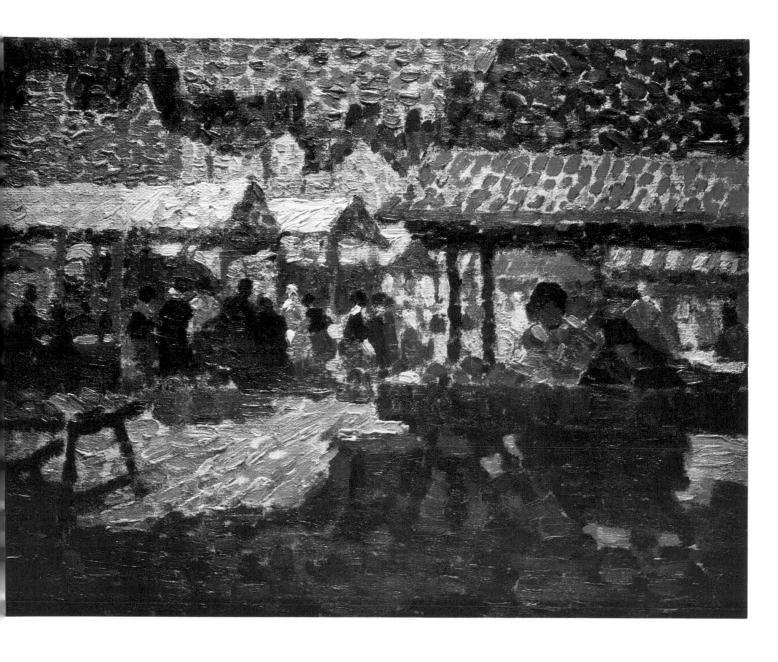

Plate XXXV. Boulogne Market, France (First Stage).

In this first stage, the painting of the market scene was rendered with evenly distributed spots of pure color. For instance, the colors used for the sky are pure blue and light crimson. They were painted directly onto the canvas, instead of being mixed together to produce purple on the palette. On looking at the reproduction, one will see that each portion of this picture was treated with precisely the same method as the sky. Occasionally two harmonious colors were placed in close proximity instead of two contrasting colors. This is noticeable on the higher buildings on the top left side, and also on the sunlit road below. Further information is given in Chapter Thirteen.

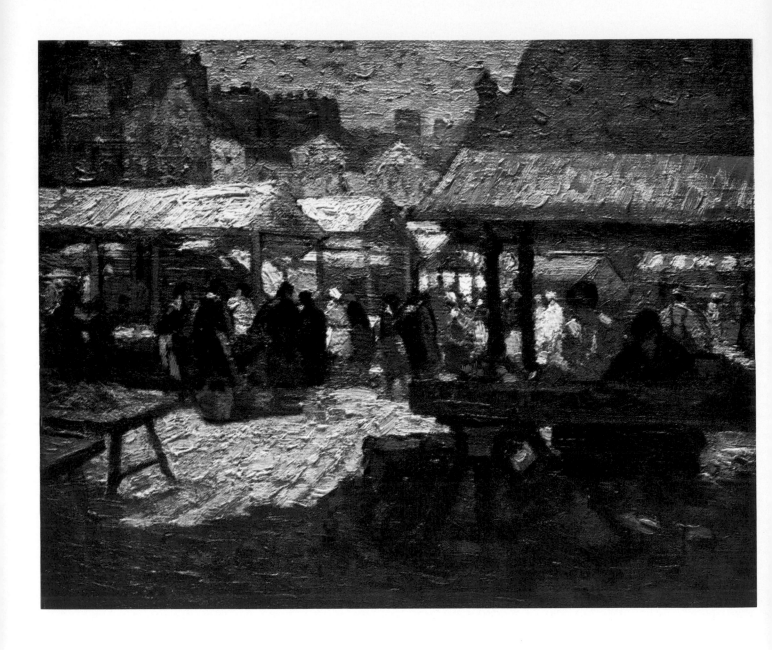

Plate XXXVI. Boulogne Market, France (Final Stage).

The impressionistic method is comparatively simple in the finishing touches, provided that in the first stage the various color daubs are placed in their correct positions. A series of neutralizing grays, both warm and cold, with occasional touches of light colored oil pigment, were painted as far as possible between the original color spots, and sometimes one color was scumbled or dragged over the color underneath. Over-indulgence of the scumbling method is apt, however, to destroy the direct color spot effect. Full information is given in Chapter Thirteen.

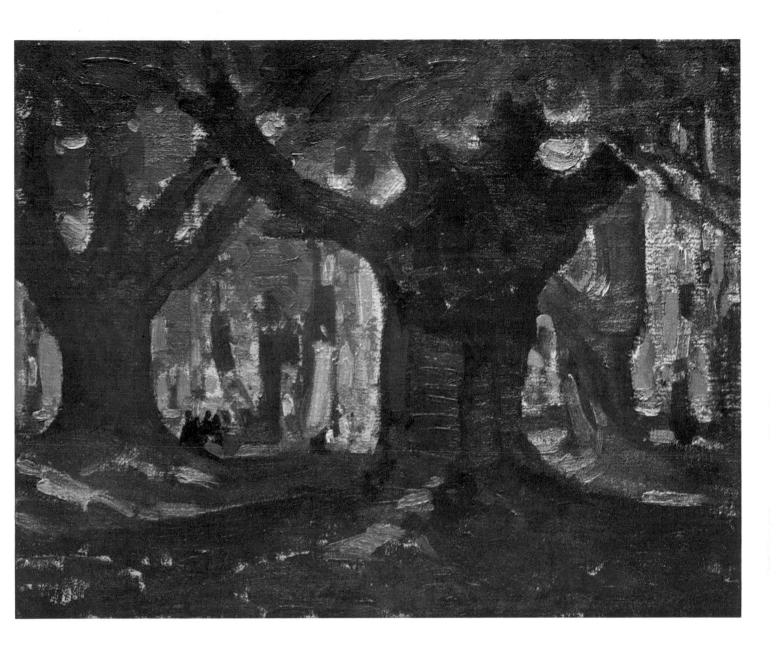

Plate XXXVII. Burnham Beeches (First Stage).

This painting was made by mixing colors directly from the tubes, and leaving out any liquid medium such as turpentine, copal varnish, or linseed oil. An excellent surface can be produced without the adventitious aids of liquid media, and transparency is also aimed at through the same simple means. The three larger tree trunks—in addition to the ground below—clearly demonstrate the effect of transparency. In the first stage, strong oil brushes should be used to control the thick oil pigment.

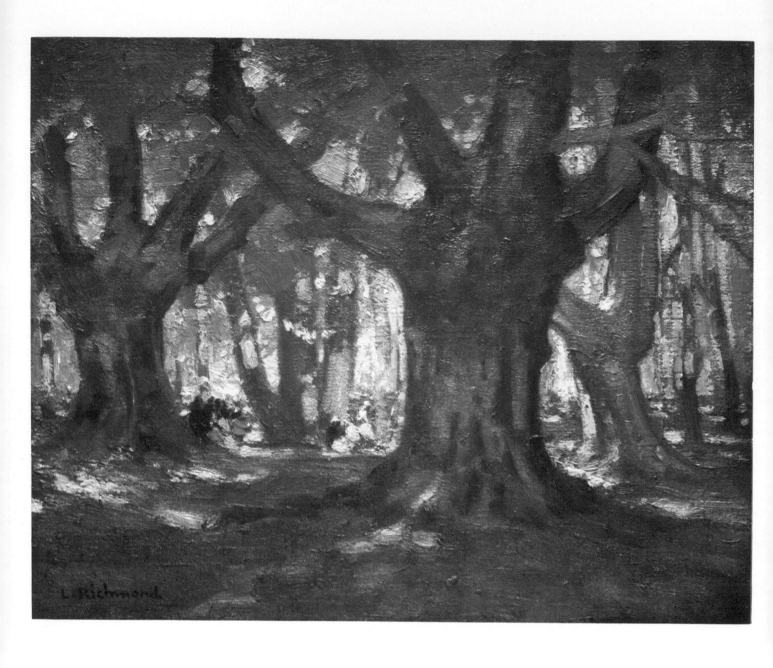

Plate XXXVIII. Burnham Beeches (Final Stage).

Although no medium was mixed with the oil pigment in this final stage, the various colors employed offered no difficulty in the technique of brush handling. The lack of liquid medium proved advantageous, as far as the broken patches of light on the trees and the distance behind were concerned. The comparatively dry pigment, when spread over the smoother ground colors, suggested a pleasing surface, somewhat similar to pastel texture. Detailed information is given in Chapter Fourteen.

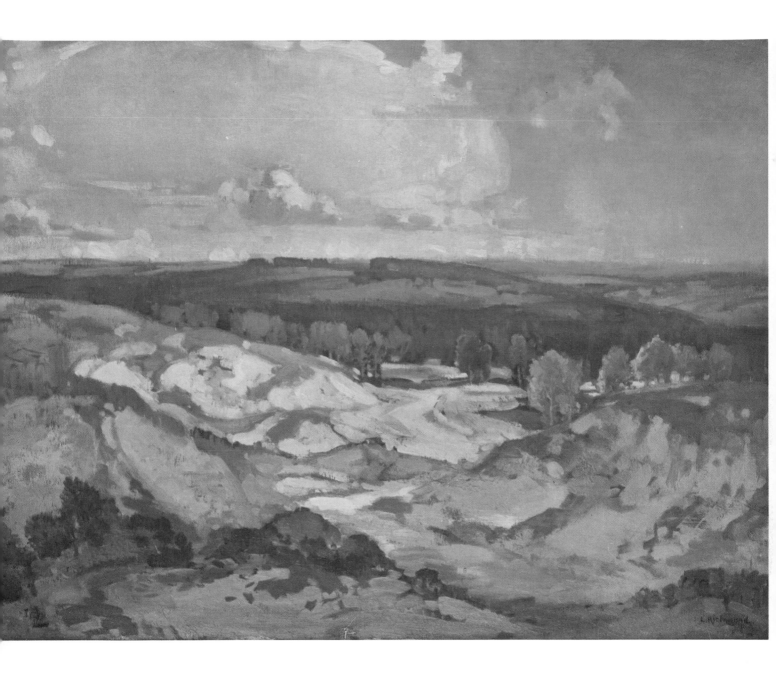

Plate XXXIX. Pas-de-Calais, France.

This picture, a series of undulating sand dunes in the foreground and middle distance, was chosen as an example of the suitability of oil painting for representing a difficult subject in which sensitive tones need accurate observation. The sunlit portion of the sand dunes is lighter than the sky. There are various silver grays adjoining this part of the picture, which necessitated some thought and experimental color mixtures on the palette before the actual painting. The dark toned distance proved comparatively easy to manage.

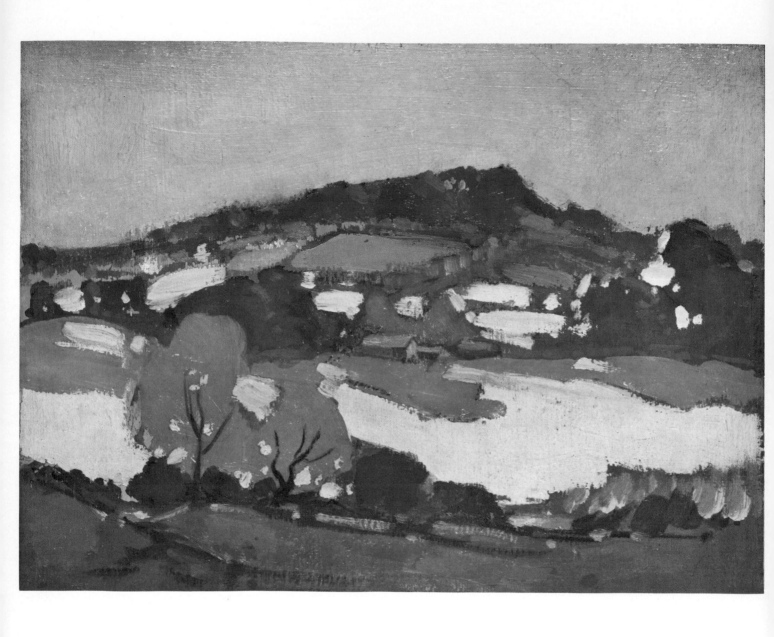

Plate XL. An Example of Incorrect Tones.

This picture is jumpy in tone, and lacks refinement in color values. The bright yellow field spreading horizontally across the landscape separates—through too strong a contrast—the foreground (at the foot of the picture) from the distant hill above. The pattern made by the various fields lying on the slope of the hill is very assertive, and disturbs the general tonality of the subject. Further information in Chapter Fifteen.

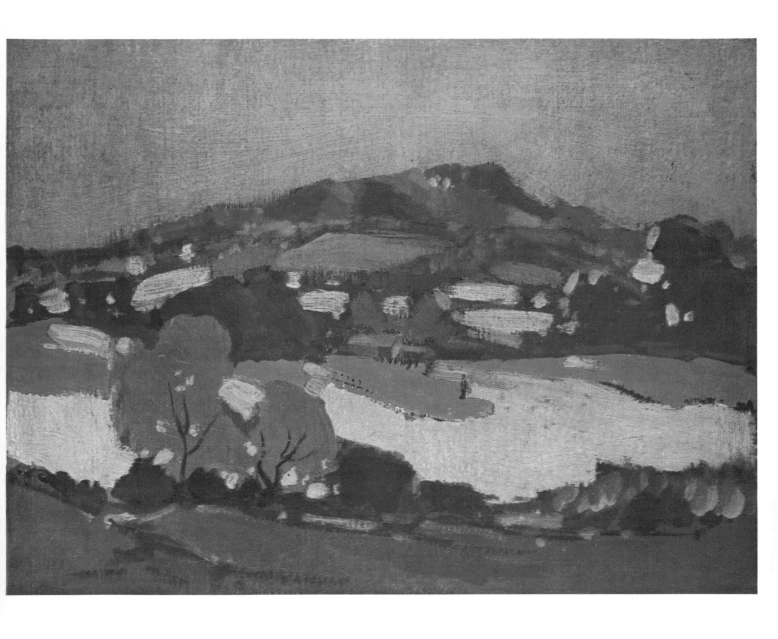

Plate XLI. An Example of Harmonious Tones.

This reproduction is precisely the same picture as Plate XL. No alterations were made with paintbrushes, yet in a few minutes the whole tone of the picture was completely changed by rubbing gently over the surface with a soft rag, which had previously been dipped in a mixture of raw sienna and copal medium. Under this treatment, the highlights became deeper in tone, thus helping to subjugate the sudden contrast between bright sunlight and dark shadows. Further particulars are given in Chapter Fifteen.

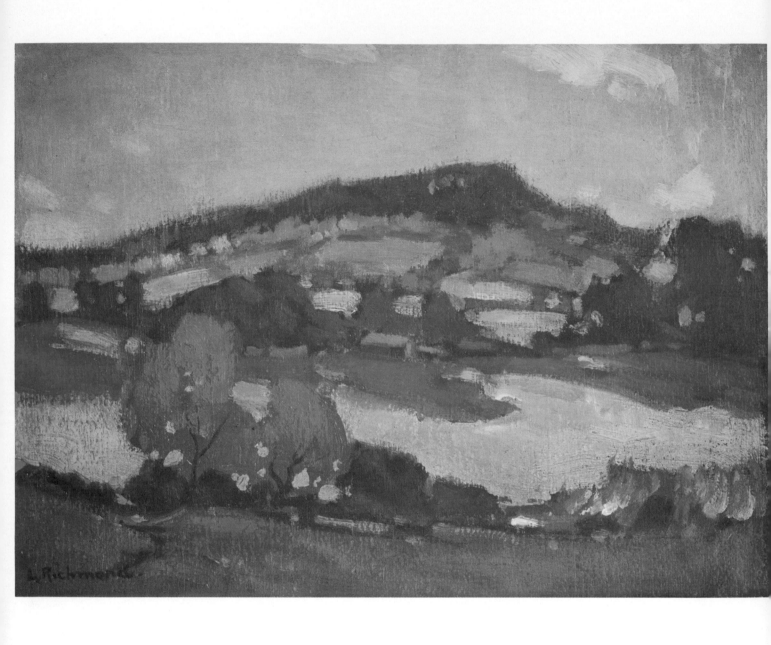

Plate XLII. An Example of Harmony with Contrast.

Little difficulty was experienced in finishing this subject which was begun in Plate XL. A small-size sponge, dipped in turpentine, was used for washing off the raw sienna in certain portions of the picture—particularly the sky—care being taken to keep the sponge as clean as possible during the process. On comparing this reproduction with Plate XL, various alerations will be discovered. The sky was lightened with a few touches of blue, as well as light gray. Clouds were then suggested, and the distant hills modified in tone. Several delicate touches of color on other parts of the canvas completed the picture, without destroying its harmony or contrast.

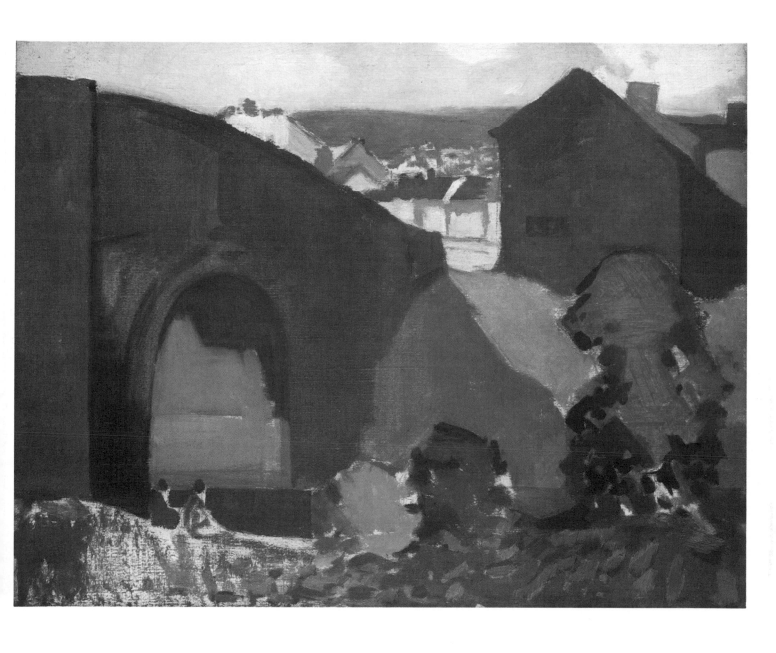

Plate XLIII. The Bridge, Charmouth, Dorset (First Stage).

This is the first stage of a picture painted entirely with matt colors, which were well diluted with rectified turpentine, and applied on the canvas somewhat in the manner of watercolor painting. This method is fully described in Chapter Fifteen.

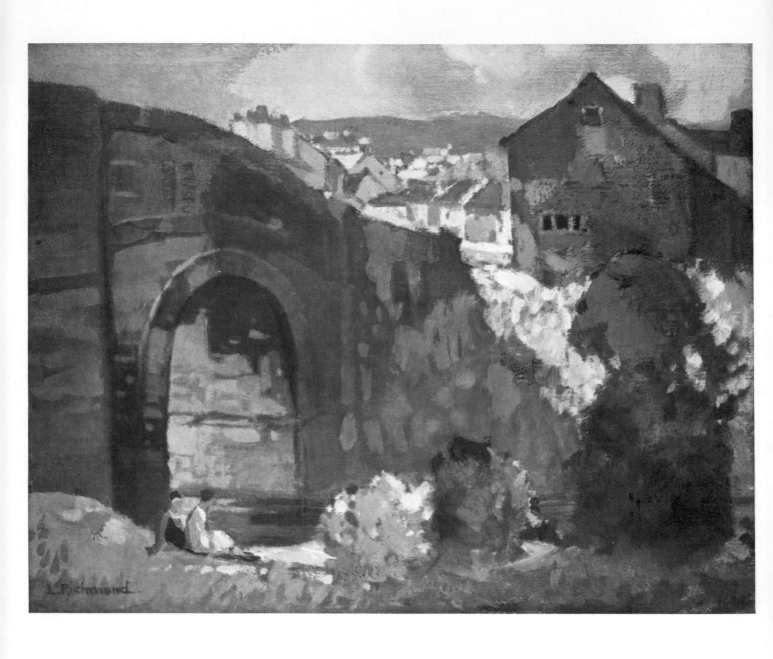

Plate XLIV. The Bridge, Charmouth, Dorset (Final Stage).

Surface textures, such as the dark wall of the cottage seen at the top right-hand side, appear without conscious effort, when one is painting with heavy, undiluted color. In the final painting of a picture, it is not necessary to invoke the aid of turpentine as a medium, since the colors—directly from the tubes—offer no difficulty for painting broad effects. See Chapter Fifteen for further information.

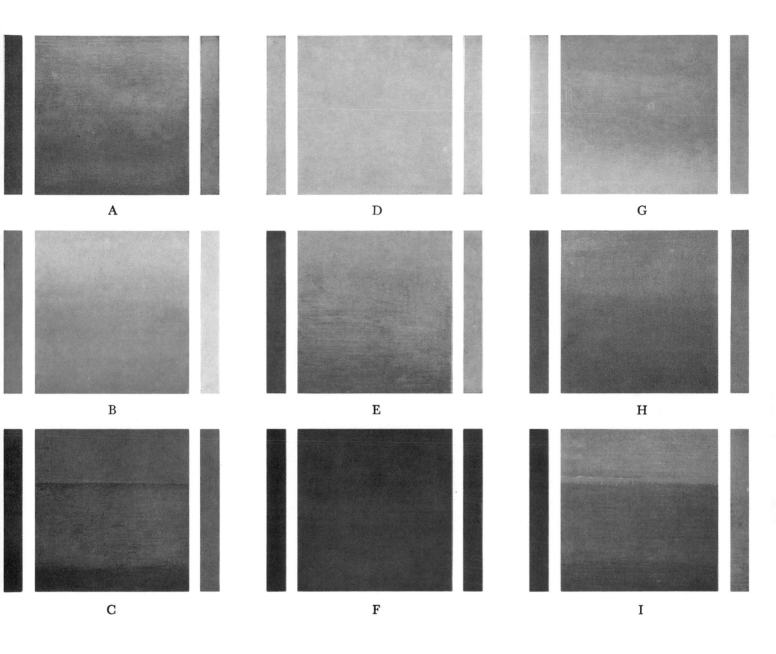

Plate XLV. Demonstrations in Casein and Oil Colors Painted Over a Gesso Ground.

The nine squares, from A to I, were each—in the first instance—painted over with a flat coat of casein color on a gesso ground. So as to identify the color used for each square, a narrow vertical band of color was placed on the left side of each square. On the opposite side of each square can be seen the color of the oil pigment which was thinly painted over the prepared casein ground. The oil pigment was well diluted with a mixture of pure turpentine and a little copal varnish. The method is described in Chapter Sixteen.

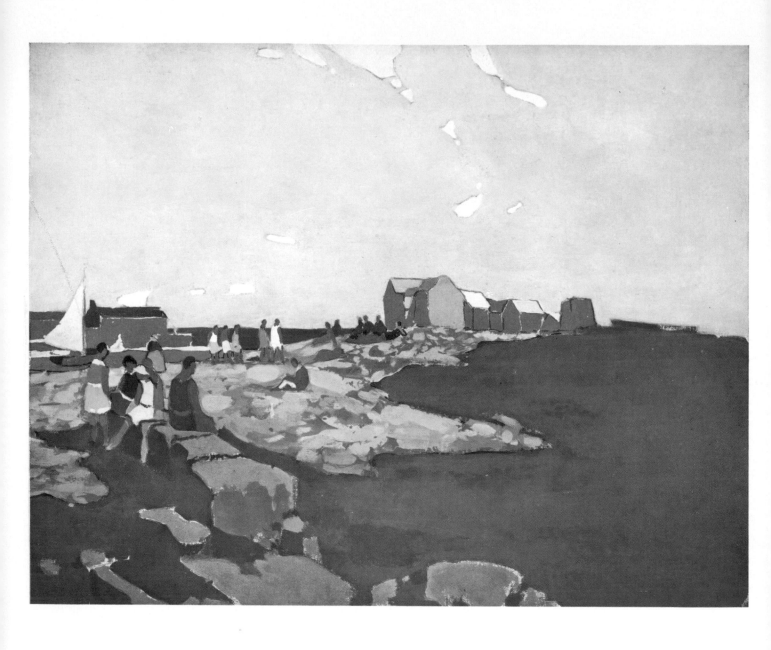

Plate XLVI. The Shore, Lyme, Regis (First Stage).

Casein colors only were used in this first stage on an absorbent gesso ground. After drying, a thin layer of copal medium was applied over the tempera ground with a soft rag, then a dry rag wiped off a good deal of the copal medium, leaving only the smallest quantity behind. Detailed information is given in Chapter Sixteen.

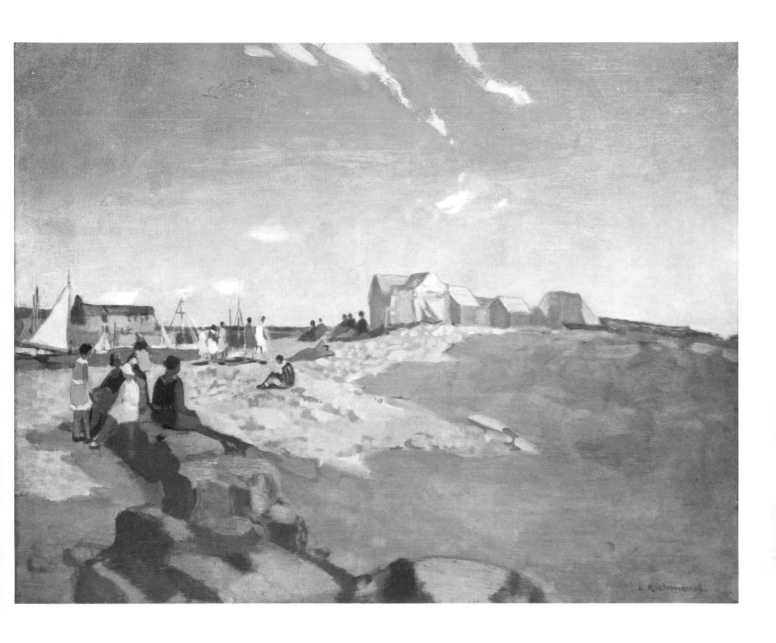

Plate XLVII. The Shore, Lyme, Regis (Final Stage).

It is most refreshing to paint in thinly-diluted oil colors over a prepared casein ground when all the problems relating to drawing, color masses, and general composition have been solved in advance. In the final stage, light and dark grays of varying tints were painted over bright patches of orange and vivid yellows, etc. The spacious sky received a thin coat of cerulean blue with flake white, and later the addition of a little yellow ochre as the sky approached the horizon. The whole method is fully explained in Chapter Sixteen.

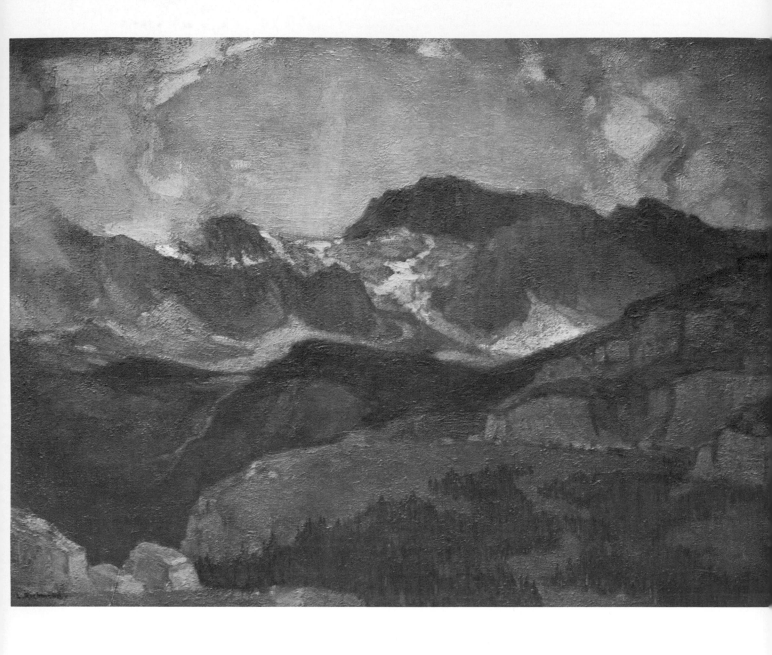

Plate XLVIII. The Dolomites.

This finished picture demonstrates the advantage of painting on a preparation consisting of fine sand mixed with whiting, water, and gelatin. This method has already been fully described in Chapter Six, as well as demonstrated in color in Plates IX and X. Very little sand was needed in the area occupied by the sky, but it was invaluable for suggesting the formation and surface texture of the mountains, and also in the foreground. There is no difficulty in getting soft or broken edges when necessary, as the granulated surface caused by the mixture of sand tends to prevent the oil pigment from completely covering the ground. Definite outlines or flat masses can be obtained when more turpentine is added to the oil pigment.

11

PALETTE KNIFE PAINTING

With palette knife painting, as in wiping out with a rag, the charm lies to a certain extent in accidental qualities. The word "accidental" in each instance is used advisedly. The painter with the palette knife must invariably be a good draftsman. A conglomeration of beautiful colors without meaning and without any instinct for draftsmanship conveys little, either to the spectator or to the artist. Yet in the initial stages of practicing this very fascinating way of expressing oil pigment, the student is advised as a preliminary exercise to play about in various colors with a palette knife, in a carefree manner, so as to achieve an easy, but convincing technique.

THE PALETTE KNIFE IS A UNIQUE TOOL

In Plate XXVIII there are four color demonstrations. The two top demonstrations (A and B) are merely powerful touches of color, placed on the canvas with the palette knife. These colors are pure tint, and placed definitely—that is to say, with decisive knife touches.

The knives used are specially supplied by art supply stores. They vary in size. The student will soon discover which size to use, but they all have the peculiar quality of squeezing color, like a workman's trowel squeezes mortar in position when laying bricks for house building.

In painting with a palette knife it is not always easy to get the desired tone, as well as the desired color, with one touch. Diagrams A and B were obtained by putting several colors one on top of the other. This, of course, gives an interesting texture, but, nevertheless, quite a good texture can be obtained with one decisive touch on a bare canvas. When a knife is heavy-laden with color and pressed against the canvas, it stands to reason that the oil pigment is squeezed outwards in every direction, thus leaving a ridge of paint all around the center of pressure. This is characteristic of palette knife handling, so that the student is advised, if he or she wishes to specialize in palette knife technique, always to bear in mind that the result should invariably look as if it had been done with a knife, and not by a brush or any other tool.

SCRAPING OFF

The two lower diagrams (C and D) in Plate XXVIII represent the variegated surface of tints when, with the same knife, the whole scheme of color is scraped away; leaving, as seen in these two diagrams, a curious stain on the canvas.

There is some possibility of this method being applied to serious oil paintings, apart from the usual palette knife work. A picture containing a background of a decoration on a wall showing several color hues, or a deep-toned tapestry of subdued hues, could be painted in thick pigment with the palette knife without showing much detail, but more with a view to general pattern and design. Then, after finishing this suggestive background in the picture, as much paint can be scraped off with the knife as is deemed advisable. The value of this method of scraping off pigment for tapestries and wall decoration, or other subject matter in the background, is that the foreground could be treated with thick pigment, giving the illusion of the foreground objects being nearer to the spectator.

In doing palette knife work, the student should have plenty of color on the palette, particularly white. The chief thing of importance, as before suggested, is purity of color touches. Consequently, some six or ten separate amounts of white, laid on the palette, mean that the student, without waste of time, can always obtain pure white paint.

LAY COOL COLORS OVER WARM GROUND

In Plate XXIX is a demonstration consisting of the (partly finished) first stage of a picture entitled *Bruges, Belgium*. The reproduction explains itself quite clearly. The whole of the picture was sketched in charcoal and then fixed with ordinary fixative. The same principle as stated in Chapter Ten, of warm and bright colors being applied first on the canvas, and the cooler colors forming the final coat of paint on top of the bright tints underneath, also holds good in palette knife technique.

In the first stage, the sky was thinly painted with the knife, using yellow ochre mixed with white. The wet yellow paint was then partly scraped off. Ultramarine blue mixed with white was painted thickly over the yellow ground, but was used less thickly in the lower portion of the sky, so that the warmer color underneath could show through and vary the tone of the sky, as well as causing an interesting color effect. No blue tint should be painted over the yellow ground where the light clouds appear, otherwise in later years the blue would affect the color of the clouds by working through the surface pigment.

Yellow ochre and orange yellow are clearly seen on the wall of the building on the left; purple, warm yellow, and brownish tints can be seen on the wall towards the right. For the clouds, white was mixed with a little yellow ochre, and placed very thickly directly onto the canvas. Deep pure blue is chiefly used for the trees, with touches of purple and brownish yellow—the blue, of course, being very dark in tone. At this stage, the pattern of the picture became quite obvious, and it was easy to suggest the color of the roofs with chrome orange and purple.

THICK PIGMENT NEEDS TIME TO DRY BETWEEN STAGES

After finishing the first stage, that is to say, when all the colors were laid entirely over the whole canvas, the canvas was put away for a long period, and allowed to dry thoroughly. The paint was then very easily applied on top of the dry

surface for the final stages of the picture. Plate **XXX** shows admirably the sense of vibration, which is one of the peculiar characteristics of palette knife handling. One can work with supreme confidence when using delicate grays of various hues on top of a warm groundwork, such as the yellow ochre and other warm tints seen in Plate **XXIX**.

ADVANTAGES OF PALETTE KNIFE PAINTING

An advantage of palette knife painting is the ease with which bright colors can be spread over an unpleasant tint. This can only be done when the under paint is wet, so that the top layer of pigment mixes with the color below. Any student, whether used to oil painting or not, will invariably find that a very interesting texture appears, in either figure or landscape subjects, when painted solely with a palette knife. Sometimes the temptation arises to use a paintbrush, particularly in depicting a small window in a building or a delicate branch of a tree, or some other minor detail, but this feeling should be sternly repressed, because the brush has no affinity with the knife as regards the peculiar texture that a knife alone can demonstrate.

TEXTURE

Although a very stringent surface can be obtained with a knife, it is also possible to get a more refined and less conspicuous texture. However, it is practically impossible to achieve palette knife paining without *any* texture, and even if it were, it would not be advisable to attempt it.

In Plates **XXXI** and **XXXII** are two more palette knife pictures. When beginning the woodland scene, I had practically no idea what the result of the first two touches of purple would be. A few more touches created the illusion of trees, so the subject was carried to a more complete stage. Several mistakes in tone were easily remedied by adding more paint on top of paint, or scraping and repainting. No paintbrush could achieve quite the same result as the palette knife in this little sketch.

Plate **XXXII**, which represents moonlight on an ancient castle, is about as far as the artist was able to go in the direction of keeping down the textures caused by the palette knife. The sky and distant view were obtained by scraping the pigment off after a fairly thick layer had been previously painted. The trees in the foreground were loaded to a certain extent with pigment. Like all moonlight subjects where buildings are concerned, there is a suggestion of delicate green, light warm purple, and yellow, where the light of the moon is seen on the castle. The trees were very dark purple, black, and pure viridian, and similar colors were used at the extreme foot of the picture.

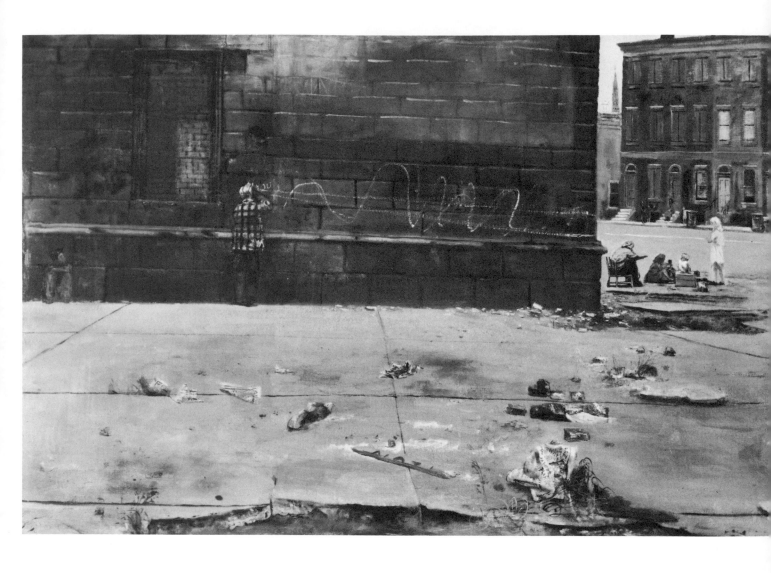

The Wall by Walter Stuempfig.

The bleak, shabby landscape of the modern city is hauntingly expressed in the design of this canvas. Virtually the entire lower half of the picture is bare pavement, broken only by an occasional crumpled newspaper or bit of trash. Most of the upper half is equally bleak: just a bare wall, animated by a single figure who draws a chalky scrawl across the stones. Only in the upper right-hand corner is there some sense of life, where a bit of sky breaks through and several figures appear in the distant street. The texture of the pavement and the wall is subtly painted with scrubby brushstrokes, leaving a trail of broken color; the painter has not diluted his colors with much medium, which would produce slick, flowing paint—obviously wrong for a subject which demands fairly stiff, dry color. The result is often a stroke which resembles a drybrush texture in watercolor. (Collection Pennsylvania Academy of the Fine Arts, Philadelphia.)

12

SCUMBLING

Scumbling, or dragging comparatively dry oil pigment over a surface that has been previously prepared with oil paint, presents an entirely different effect from glazing. In the latter, a luminous transparency is noticeable; in scumbling, the opposite effect is gained. This method of oil painting can make a flat color tone appear quite lively through the sparkling effect caused by innumerable little touches, or spots, of oil pigment which adhere to the outer surface or protuberances of the colored canvas below, leaving untouched the more sunken portions of the under painting.

THE GROUND In Plate XXXIII, the four examples of scumbling (A, B, C, D) were done on a canvas of pronounced texture. The strips of color placed underneath each demonstration represent the exact ground color that was first painted—or rather stained—on the surface. The narrow band of color placed above each example shows the color used for scumbling over the ground tints. There are no solid oil pigments in the ground tints. They are only color stains, made through a generous mixture of mineral spirit with oil pigment, which are washed over the canvas and allowed to dry thoroughly, in precisely the same manner as in pure watercolor painting. This method is also shown in Plates VII and XXVI.

STAINING THE GROUND The slightest suggestion of solid oil pigment in the dark ground tints would eventually prove fatal to the lighter colored oil pigment above, as under those conditions the lower colors would—in later years—affect the surface colors, and lower their tone, with disastrous results to the original conception of the artist. Should any doubt arise as to whether the ground color is more solid than a legitimate transparent stain, one can soak a rag slightly in mineral spirit, and rub it gently over the colored canvas until there is no evidence left of any solid patches of oil paint.

Mineral spirit is an excellent medium for oil color staining, and serves its purpose much better than a mixture of linseed oil, turpentine, and copal varnish. Linseed oil and copal varnish remain with the color pigment, instead of evaporating like mineral spirit. Their presence tends to do more harm than good for staining purposes.

The colors used for scumbling (above examples A, B, C, D in Plate XXXIII) were each painted very lightly and delicately in a horizontal direction across

the stained surfaces of A, B, C, D with a bristle brush, about ½″ wide. No oil medium was used for any of these four demonstrations, nor for the examples in Plate XXXIV. The drier the oil pigment (provided that it is workable with a brush), the easier it becomes to achieve a genuine scumbling effect, as the dry pigment—through lack of oil moisture—is unable to sink into the lower crevices of the canvas, and only adheres to the outer or textural portions. A spotty or vibrating appearance is thus left, which is characteristic of this method.

Students will probably find the filbert shape brush the best for this purpose, since the edges are slightly rounded; but much good work can be accomplished with an ordinary square brush, although care must be taken to avoid leaving a noticeable ridge of paint which is liable to be caused by the outside edges of this type of brush.

USE A TEXTURED SURFACE

Most painters make the discovery that their first attempts at scumbling are far removed from success. It is a technique that requires considerable practice. Smooth canvas should be avoided in the early experimental stages, as the problem becomes more complex, especially when one is working over a stained instead of on a solidly painted ground. Buckram (see Chapter Six) offers no difficulties in this method of painting. In fact, it is the best material to commence with, and later it should pave the way to successful scumbling on fairly coarse canvas. A surface made with whiting, sand, and gelatin, as advocated in Chapter Six, is also very good for scumbling effects. The granulated or textural surface caused by the use of sand makes an admirable ground, over which dry colors can be dragged with excellent results.

COLOR MIXTURES FOR SCUMBLING

The following color mixtures were used for Plate XXXIII:

(A) *Ground color* (band at bottom of A) was made by mixing burnt sienna and a little white; *the color used for scumbling over* (band at top of A) was made by mixing orange chrome with a touch of burnt sienna and white.

(B) *Ground color* (band at bottom of B) was the same as the color used for scumbling over A; *the color used for scumbling over* (band at top of B) was a mixture of yellow ochre, deep chrome, orange chrome, and white.

(C) *Ground color* (band at bottom of C) was made by mixing alizarin crimson, cobalt blue, and white; *the color used for scumbling over* (band at top of B) was a mixture of yellow ochre, a little ivory black, and white.

(D) *Ground color* (band at bottom of D) was made by mixing ultramarine blue with the smallest portion each of alizarin crimson and white; *the color used for scumbling over* (band at top of D) was a mixture of alizarin crimson, ultramarine blue, a spot of yellow ochre, and white.

SCUMBLING OVER PATTERNED COLORS

The examples marked B and C in Plate XXXIV were painted all over with exactly the same strong colors and pattern suggestions, as seen in the *lower* section of each example. Mineral spirit only was used as a medium with the oil pigment. The less oil contained in the color pigment the better, provided, of course, that it has sufficient oil mixture, so that the paint can adhere to the surface of the canvas; otherwise the acidity contained in an excess of oil is very liable to burn the absorbent canvas below. The ground colors of B and C were left until thoroughly dry before scumbling was commenced. Then a mixture of lemon yellow (A) with ivory black and white was scumbled over the ground colors in B: lemon yellow, cobalt blue, alizarin crimson, each mixed with a little white. The ground colors in C—Chinese vermilion, deep chrome, viridian mixed with white, and ivory black—were scumbled over with the mixture in D: light red, yellow ochre, a touch of middle chrome, ivory black, and white.

The color seen in A was used for scumbling the upper two-thirds of the area space of B with a wide brush. A beginning was made at the top portion and the paint was dragged across in an horizontal direction over the prepared surface. This preparatory surface, which is also demonstrated in C, was painted with solid touches of oil pigment, so as to get a good texture, thus enabling the scumbling colors to function in a broken or vibrating style.

It is noticeable that the central section of B is less opaque in appearance than the higher portion. This was made by soaking a rag in mineral spirit and rubbing it lightly over the scumbled surface while it was still wet.

The color marked D was used for scumbling the upper half of the prepared ground tints of C, the brush being used lightly in the same horizontal direction as before. The result is a most suggestive effect of broken color, which neutralizes all the vivid and pronounced colors below.

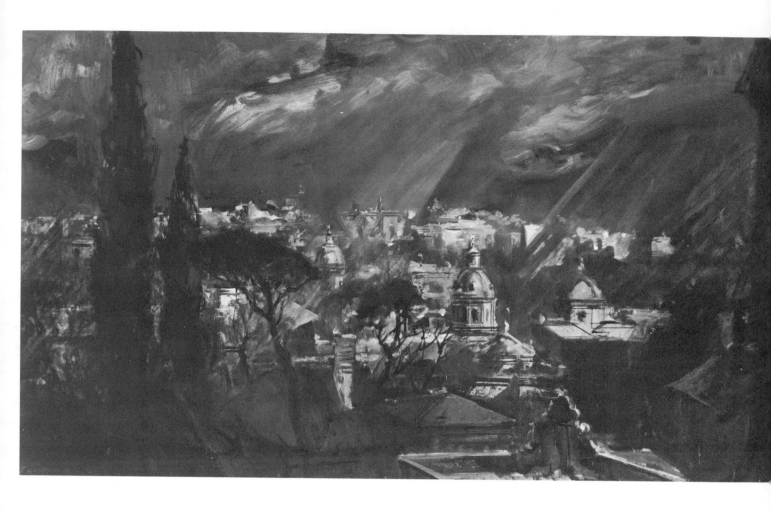

Storm Over Rome by John Annus.

The entire tone of this turbulent landscape is set by the storm, which is painted in large, free-flowing strokes which not only form the sky, but infiltrate the buildings below. The buildings seem to emerge from a storm of brushstrokes which partially conceal them, revealing a dome or another architectural detail here and there. The light effect is a product of far more careful study than one might suppose. The artist has carefully examined the direction of the light that breaks through the stormy sky and has used the slanting beams of light to spotlight selected details of the landscape. He has restricted the spotlight effect to the distant landscape, keeping the nearby trees in shadow, so that they frame what lies beyond. Notice how the tempestuous sky and distant city are carefully surrounded by a cluster of dark, silent trees to the left, and a dark, nearby wall at the extreme right-hand edge of the canvas. A storm always looks stormier if there are areas of calm like the majestic forms of the poplars. (Photograph courtesy *American Artist.*)

13

COLOR
VIBRATION

The French impressionists evolved a method of painting outdoor subjects wherein the feeling of pulsating sunlight is represented in daubs of pure contrasting colors, placed in close proximity to each other, and eventually filling up the whole canvas as depicted in the first stage of *Boulogne Market, France* (Plate XXXV).

The colors used for the warm tints in the first stage (Plate XXXV) were lemon yellow, yellow ochre, middle chrome, orange chrome, and burnt sienna. For the cool tints, viridian, ultramarine blue, and cobalt blue were used. Purple was made by mixing alizarin crimson and cobalt blue with a little white. The same crimson and blue were each mixed with white for the color touches in the sky and elsewhere.

The subject was very carefully drawn in charcoal, as all the daubs of color pigment had to be placed in their correct positions, thus helping to build up a constructive design; otherwise there is a danger of losing the leading features of the picture.

LAY A GROUND OF BRILLIANT DAUBS OF COLOR

The first stage (Plate XXXV) demonstrates the possibilities of obtaining a sparkling glitter, caused by the above mentioned method of pure color touches on a canvas of decided grain. To paint in this style gives one an esthetic thrill. No student or experienced artist should neglect some exercise in oil painting along the lines seen in the reproduction of the first stage. Many contrasting colors spread over a whole canvas—which through adroit treatment are made to harmonize—give a great deal of vitality or movement to an oil pigment surface.

The feeling of vibrating color so characteristic of this method of painting often produces a profound influence on other styles of oil painting, and an artist with dull tendencies in color pattern, combined with the lack of interesting paint textures, could not do better than paint for a time in this manner. It is a healthy tonic and one that should prove most beneficial.

PULL YOUR GROUNDWORK TOGETHER

The final stage should not be attempted until the first painting is thoroughly dry. Plate XXXVI shows how the various color daubs are brought together, or united, by painting in and around them, and also through partly dragging or scumbling a neutral color over the surface of the ground colors underneath.

The sky was lightened with cobalt blue mixed with white, also a little yellow ochre and white. Notice how the original reddish ground, although partly sub-

merged, still displays its presence in the final painting. The general lighting effect of the sky brings the different colors up to their correct tones. A good deal of warm gray was painted lightly over the distant buildings, so that they might retain their place in tone, which is behind the foreground market scene. Other bright colors were also modified by dragging light and dark neutral tints around and partly over the original ground colors.

IMPORTANCE OF BRIGHT GROUND TINTS Painted on the theory that the colors in the first layer eventually work their way through to the outer surface of oil pigment, this market scene picture, in spite of some lowering of tone through the oil already mixed with the tube pigment, should retain its bright sunlight effect for a long period, thanks to the brilliant tints seen in the first stage.

14

Nearly all artists, when painting with oil pigment, use a considerable amount of liquid medium, so as to make the colors work more freely. Very rarely does one find a painter using the colors directly from the tube, without the assistance of some medium for thinning purposes.

It is surprising what can be accomplished in oil painting *without* the aid of turpentine, linseed oil, and copal varnish. Students' experience in the technique of oil painting would not be complete unless they painted several pictures or sketches in which the oil medium is entirely ignored; even assuming that they are now already acquainted—through actual practice—with all the other examples in this book.

USE A STRONG BRUSH

It is not so easy when painting in this method to successfully manipulate the oil pigment in the first stage, and it naturally needs more time; but after the preliminary painting is dry, or even working into wet colors, the student will find that the oil pigment moves more freely, while the brush adheres very readily to the colors underneath, thus requiring less pressure. The whole subject must be painted in with strong brushes possessing short hairs and good resisting power, since more speed can be attained with this type of bristle brush. The long haired variety of oil paintbrushes are too weak to be of any value in manipulating thick, undiluted oil paint.

IMPORTANCE OF GROUND COLORS

In the first stage of the picture entitled *Burnham Beeches* (Plate XXXVII), the colors were painted directly onto the canvas. After the pigment was well spread out with strong bristle brushes, some of the colors looked unusually transparent, despite the absence of liquid medium. This is more noticeable in the dark toned trunks of the nearer trees, and in the deep foreground shadows at the foot of the picture. Pure burnt sienna and patches of purple account chiefly for the fresh and liquid color effect in the shadows. It always pays to paint the first stage of an oil picture with bright colors and flat, decided tones, but not too light in tone. If you lay on your ground colors in this way, when the final color touches are painted over them the colors below will help to preserve the purity of the top layer of oil pigment.

FINAL LAYER OF PIGMENT IS THICK, DRIES MATT

In the final stage of *Burnham Beeches* (Plate XXXVIII), the larger tree trunks were modeled with the paintbrush, to suggest a natural rotunditity, and several tones of warm and cool grays were painted over the warm tinted groundwork. The finished picture eventually dried with a matt, or dull, surface, which is by no means displeasing from an artistic standpoint. Some artists prefer painting their pictures to attain this result, instead of getting—through the use of an oil medium—a glossy, or shining, surface. Painting without any medium acts as a preservative to the colors, since oil (especially linseed oil) lowers, or darkens, the various colors. There is plenty of oil already ground with the pigment before the packing in tubes, so that considerable caution should be exercised as to the use of additional quantities.

Pictures with a matt surface, unless coated with mastic varnish, should be framed under glass to protect the outer colors from the injurious effects of dirt, moisture, etc.

Trestle by Gordon Steele.

The landscape of the city offers fascinating design possibilities for landscape painting. In this canvas, the artist has discovered that the jagged, broken geometric shapes of a tumbledown waterfront neighborhood are echoed in the shapes enclosed by the structure of the bridge. The light patches of sky which break through the steel girders echo the light patches on the walls and rooftops in the foreground. A vertical landscape is always a complex problem, which the artist has solved by placing his center of interest—the trestle—high in the picture, exploiting the vertical format to give a sense of crowding and complexity to the buildings, which build up vertically to the bridge which towers over them. The looming aspect of the bridge would have been lost in a horizontal landscape. (Awarded Purchase Prize by Syracuse Museum Trustees for the Museum Collection.)

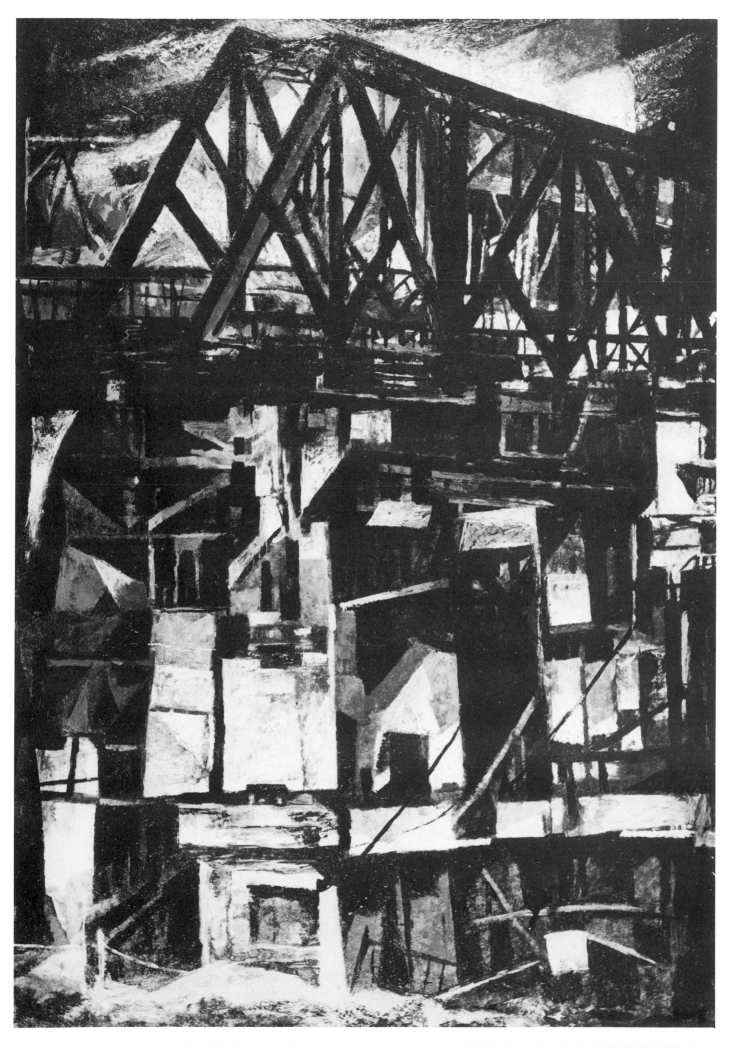

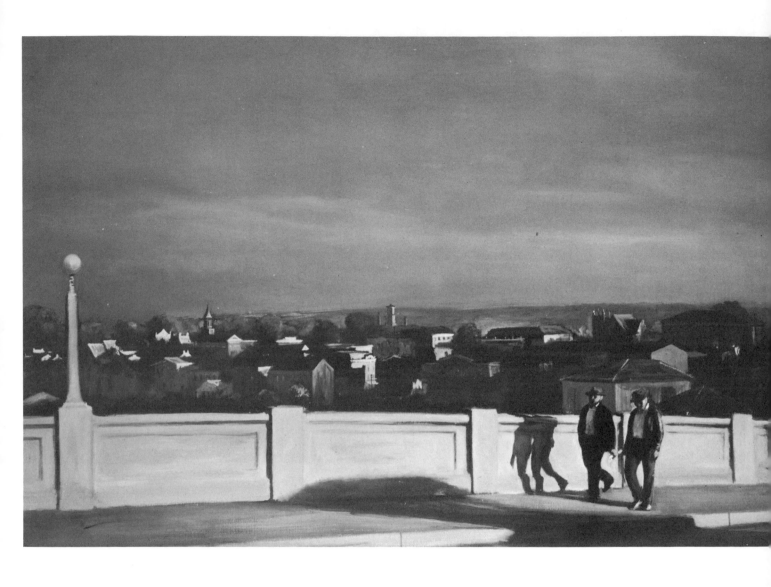

Phoenixville by Lucius Crowell.

A very unpromising composition gains mystery by the haunting use of light and space. The light enters the landscape from a low angle at the extreme right and suddenly illuminates the wall in the foreground, also catching on bits of the buildings in the distance. The walking figures are thrown into silhouette and cast jagged shadows on the wall; an even bigger shadow is thrown in front of them by some unknown object. There are strong contrasts of light and shade not only in the foreground but in the cityscape, over which broods a bare, faintly ominous sky. It is the very bareness of the sky and of the wall in the foreground, with its two lonely figures, which makes this composition so memorable. (Photograph courtesy *American Artist*.)

15

HOW TO OBTAIN COLOR HARMONY

Plate XL represents a landscape which is fresh in treatment, with a decisive pattern, but the color, with one or two minor exceptions, is garish and crude, as well as incorrect in tone. (Compare this with the sensitive tones illustrated in Plate XXXIX).

The warm gray sky shows the most refined tint in the picture, and the foreground at the foot of the picture harmonizes well with the sky. Apart from this, the rest of the subject is faulty in tone. Notice how unpleasantly the bright yellow field (with the sweeping green shadows) immediately behind the foreground contrasts with the general surroundings, being far too assertive at the expense of the tonality of the landscape. The same remarks apply to the orange and yellow colored fields seen on the slopes of the distant hill. Lastly, the general contours of the picture—such as the trees, fields, etc.—are too rigid or hard on the edges, thus destroying the charm of nature which is peculiar to the scintillating brightness of a sunlit summer's day.

BLENDING To achieve the result seen in Plate XLI, drastic measures were taken to obliterate all harsh tones. The original painting was entirely covered, by rubbing over with a soft rag carrying a thin coat of raw sienna. This color was previously mixed on the palette with copal medium. Great care was taken to avoid any suggestion of thick pigment on the original painting.

SPONGING OUT Plate XLII represents the final treatment of this picture. A small sponge, dipped in turpentine, was rubbed gently—where required—over the painting. Since the original sky was accurate in tone, most of the raw sienna in this area was sponged off, but to obtain this happy result it was necessary to keep the sponge quite clean from color for the final touches.

COLOR TOUCH-UPS Here and there a few touches of brush painting were indulged in. The sky received a suggestion of blue color, while the distant hills and trees were corrected in tone. As a rule, when this method is used, only one or two final alterations are necessary to complete the picture.

For pictures lacking in general harmony, with a consequent failure of good tones, the treatment advocated in this chapter invariably alters the aspect of the

unsuccessful picture, and sometimes, through accidental touches during sponging out, suggests possibilities of great promise for the subject in hand.

WORKING FROM THIN TO THICK PAINT

Plate XLIII represents the first stage of a picture painted with very thin color. Notice how the general dilution of rectified turpentine has thinned the pigment to such an extent that it looks somewhat like a watercolor sketch. The colors used are flake white, yellow ochre, viridian, ultramarine blue, vermilion, alizarin crimson, burnt sienna, and ivory black.

Plate XLIV shows the final stage. A good deal of painting into wet pigment was indulged in, with interesting results—scumbling or dragging one color partly over the surface of another. No medium was necessary for the finishing touches in this picture. The colors used for the final stage are: flake white, chrome yellow, yellow ochre, cadmium, alizarin crimson, burnt sienna, viridian, ultramarine blue, and ivory black.

As The Sparks Fly Upward
by Everett Warner.

The cluster of buildings on the near shore and on the smoky, distant landscape provide an interesting lesson in atmospheric perspective. The nearby buildings are darker, more clearly defined, more detailed, with crisper contrasts of light and dark. The distant shore, obscured by smoke and smog, is far grayer, less detailed, with much less contrast between light and dark. And even the distance is divided into several planes. In the upper right hand corner, observe how there is a medium gray shape of land beyond the last building, an even paler horizon shape beyond that, and finally the pale sky. The foreground buildings are framed in a pattern of light and dark snow and soil which spirals around them and leads the viewer's eye past them—very much as one would walk down the snowy street to the crest of the hill. (Photograph courtesy *American Artist.*)

Wooden Objects by William Brice.

The artist has assembled a group of humble objects whose geometric shapes and intricate textures suddenly come alive when they are organized in this very precise, architectural composition. Still life painting is often the art of discovering the potential in unlikely forms, as the artist has done here. What *could* be a frigid and lifeless arrangement is enriched by the thick, crusty texture of the paint, which not only catches the texture of the objects, but takes on a life of its own. Observe how every surface is intricately broken into a continuous fabric of changing tone, color, and texture. The light enters the picture from the extreme left, the classical lighting effect of still life painters who want to emphasize the roundness of their subjects. (Photograph courtesy *American Artist,* collection Mrs. Ralph Guinzberg.)

16

COMBINED TECHNIQUE: GESSO, CASEIN OR ACRYLIC, AND OIL COLORS

Oil colors are rendered considerably more permanent by being painted over a prepared surface of casein or acrylic colors with a gesso ground below. Providing the colors are bright in tint, their presence will prevent the top layer of oil colors from deteriorating in tone.

With the advance of time, oil pigments become thinner and more transparent, so that the colors below eventually begin to assert their existence through the film of oil pigment above. Hence the reason for using bright casein or acrylic colors in preference to drab or gray tints.

As regards the gesso ground, it is safer to have Masonite panels for casein paint, but if acrylic gesso is used, canvas can be manipulated to advantage as for acrylic paints.

The various demonstrations and pictorial matter of Plates XLV, XLVI, and XLVII were painted in oil pigments on a casein ground with a gesso priming. The nine demonstrations seen in Plate XLV convey a wide range of the possibilities of the combined use of gesso priming, casein or acrylic ground, and oil painting.

LAYING A CASEIN OR ACRYLIC GROUND

Casein and acrylic colors can be purchased in large tubes, about 4″ long. Water only is necessary as a medium for thinning these colors. After the casein or acrylic is thoroughly dry (it takes at least one day), a very soft rag should be used—dipped in copal medium—and rubbed gently over the surface, followed by a clean rag, so as to wipe off any excess of oil. This will give a good preparatory ground for the thin oil painting.

COMBINED TECHNIQUE IN PRACTICE

Referring to Plate XLV, the nine colored squares (marked A, B, C, D, etc.) were originally painted in casein, the colors of which can be seen immediately on the *left* side of each example. The following colors were used:

(A) Cadmium orange.
(B) Oxide of chromium and light cadmium yellow.
(C) Alizarin crimson and cobalt blue.

(D) Zinc yellow.
(E) White, cadmium orange, and ultramarine blue.
(F) Burnt umber and a little white.
(G) Yellow ochre and flake white.
(H) Cadmium vermilion
(I) Ultramarine blue and a little white.

The oil colors used over the casein ground can be seen immediately on the *right* of each demonstration. The following oil colors were used:

(A) Flake white, yellow ochre, and ultramarine blue.
(B) Pale chrome yellow and a little flake white.
(C) Rose madder and flake white.
(D) Flake white with a little yellow ochre.
(E) Yellow ochre and flake white.
(F) Burnt sienna and a little flake white.
(G) Cerulean blue and flake white.
(H) Deep chrome yellow and chrome orange.
(I) Flake white, chrome orange, viridian, and ultramarine blue.

The medium used with the oil colors consisted of turpentine mixed with a little copal varnish. The oil pigment was thinly painted over the casein ground, particularly in the lower portion of each square. A little variety was given in the two squares marked C and I, where the suggestion was made of contrasting tones, instead of gradating the colors, as seen in the other examples.

When painting the subject entitled *The Shore, Lyme Regis* (Plate XLVI), exactly the same methods were adopted for this picture as those which have already been fully explained and also demonstrated on Plate XLV. The colors used for the first stage consisted of white, cadmium yellow, yellow ochre, cadmium orange, viridian, alizarin crimson, burnt sienna, and ultramarine blue.

The more important oil colors used for the final stage (Plate XLVII) were cerulean blue and flake white for the top of the sky, with the addition of a little yellow ochre as the color gradated towards the horizon. Light tinted warm and cold grays were invaluable for painting over the large foreground shadow and also over the various touches of orange and yellow so noticeable in the first stage. Flake white mixed with bright yellows, etc., helped to accentuate the sunlit portions of the picture.

Wilde Street, Manayunk
by Antonio P. Martino.

To paint what appears to be a simple cityscape—essentially a collection of flat, geometric shapes—the artist must have an excellent command of perspective. This is a particularly complex piece of perspective since the buildings wander downhill and then uphill again. Thus, there is not one vanishing point, but a series of vanishing points, one above the other, along an imaginary vertical line that runs down the snowy street from the horizon toward the foreground. It may be worthwhile to take a ruler, a pencil, and a sheet of tracing paper in order to determine exactly where these various vanishing points are. The light falls from above on the snow-covered rooftops, creating a lively pattern of bright shapes, contrasting sharply with the shadowy walls that face the viewer. To avoid a feeling of monotonous symmetry, the snowy street is just off center, while a nearby building breaks the horizon to the right and ascends to the very top edge of the picture, where the rooftop is cut off by the frame. (Collection International Business Machines Corp.)

Snow Flurries by Everett Warner

Landscape painters too often neglect industrial subjects. Here the shapes of industry are combined with flurries of white snow, light and dark smoke, and elements of the natural landscape. The complex composition is divided carefully into planes: the rocky, snow-covered hills in the immediate foreground; the industrial buildings and tanks in the middle ground, interrupted by the snow flurries and smoke; and the distant landscape, interrupted once again by snow and smoke. The drama of the composition is enhanced by the alternation of light and dark: the white snow flurry against the dark shapes of the tanks, which are silhouetted, in turn, against the white snow beyond. Notice the rough texture and heavy consistency of the paint in the immediate foreground in contrast to the softer strokes in the middle distance. (Collection International Business Machines Corp.)

17

OIL COLORS
AND MEDIUMS

This chapter is devoted to a brief—but important—description of various colors and oil mediums. The acquisition of knowledge in this direction is of great advantage to the serious artist who has already achieved the necessary skill in the technique of oil painting.

COLORS *Flake white* is very pleasant to use. Although it is quite a solid pigment, it also offers no opposition to easy brush handling. For this reason, students are strongly advised to use flake white at the beginning of their career in preference to zinc white.

Zinc white dries more slowly than flake white, but it becomes very hard when quite dry, and is the more brilliant of the two whites. It is, however, somewhat difficult to handle, and students are advised to master flake white before attempting this somewhat stodgy and heavy material. It is more permanent than flake white, although it cracks more easily, and is excellent for strong highlights, or for making a thick impasto on canvas or wood.

Lemon yellow can be obtained in two or three tints. It is the most effective yellow of all the series of delicate tones.

Chrome yellows range from light to an orange tint. They appear to be reinstated again on artists' palettes, since considerable evidence has been produced in their favor as possessing permanent qualities. They are inexpensive, and mix excellently with other colors, being strong and forceful when used in any color combination.

Cadmium yellows, like the chromes, range from light to dark yellow, approaching an orange tint, and are absolutely permanent.

Vermilion is a color which is greatly improved, thanks to modern science. Chinese vermilion is almost pure from a chemical standpoint. It can be safely mixed with pure white lead without any change. Vermilion, like cerulean blue and chrome yellow, is a strong and solid color with opaque qualities.

Crimson and red lakes. Crimson lake should be strictly avoided, but alizarin crimson (alizarin is now made artificially) can be used by painters with safety. Modern chemists, after careful testing, believe it to be permanent. Rose madder, al-

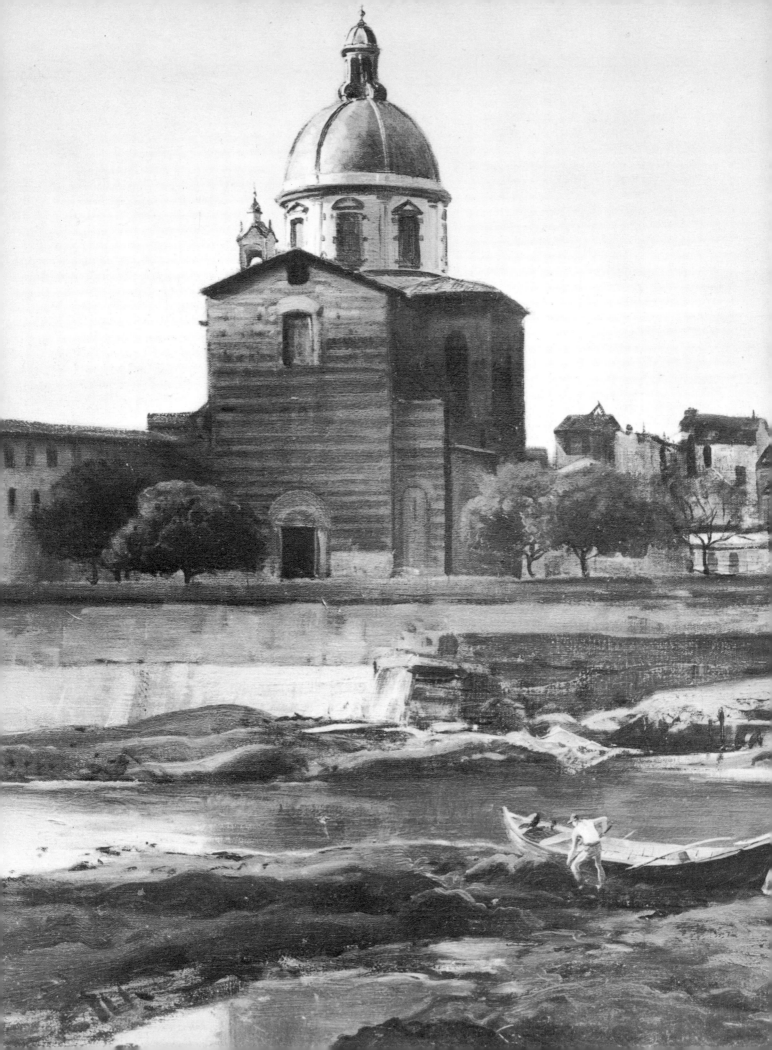

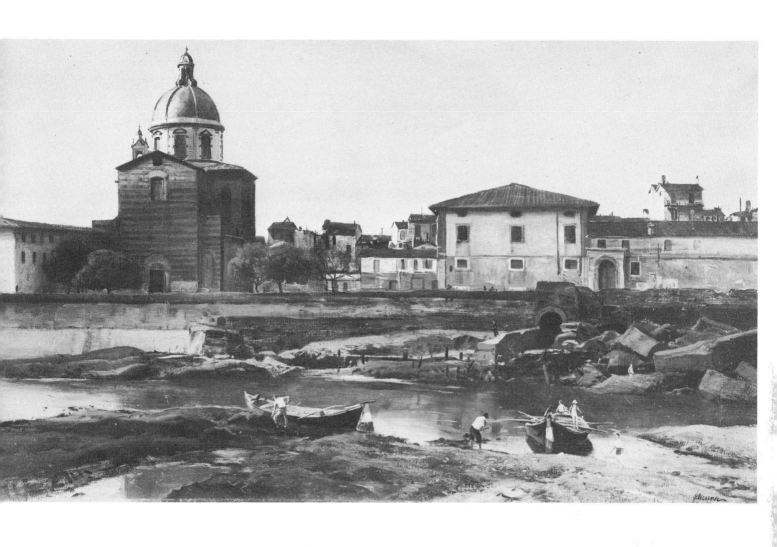

The Arno by Ogden M. Pleissner.

The dome of the church breaks upwards suddenly from the horizontal composition, which consists almost entirely of parallel strips of land, water, and walls. Yet one never has a feeling of sterile geometry because every part of the picture is enriched by lively brush textures, animated figures, flashes of light on walls and water. At first glance, this urban landscape seems filled with detail, yet when one looks more closely, each detail has been simplified to blend into the total compositional scheme without distracting the eye. Windows are mere patches of light and dark; figures have no features; rocks are broken into flattish planes; and trees are blurs of color which melt into the walls beyond. The complexity of the townscape is offset by the extreme simplicity of the sky. (Photograph courtesy *American Artist.*)

though bright and delicate in color, lacks the staining power of its more formidable rival, alizarin crimson.

Cobalt blue is absolute permanent. It is a bright color, and owes its existence to comparatively modern chemistry. At the same time, owing to its transparency, very little linseed oil should be added as this would seriously affect the original color through the yellowing process of the oil.

Ultramarine blue (an artificial ultramarine), like cobalt blue, was discovered in the early nineteenth century in France. The student will find ultramarine blue one of the most useful of all the blues for painting purposes. The darker varieties are very rich, and unless mixed with white, are quite deep in tone. It is slightly more opaque than cobalt, and is quite permanent.

Cerulean blue is an opaque color which is used very little in comparison with ultramarine blue. On the other hand, it is quite permanent, and is often useful for certain portions of a picture.

Oxide of chromium (*viridian*) is a most vigorous permanent green, and strong in color. Much can be achieved with viridian, particularly in landscape painting. Mixed with white, it almost approaches the hues of emerald green. When mixed with light chrome or lemon yellow, as well as white, it is capable of expressing most sensitive and interesting tints.

Emerald green is a lovely color—inexpensive—but viewed with suspicion by most artists, who believe it to be non-permanent. On the contrary, it is permanent unless mixed with either cadmium yellow or vermilion. The presence of arsenic in emerald green makes it very poisonous.

Ivory black is preferable to other types of black. It is quite permanent, but dries rather slowly. It is the richest of the blacks and mixes well with other colors.

The remaining colors described in this chapter are known as "the earth colors." These pigments are very good for oil painting—being entirely permanent. They have good body and are useful in most pictures as the colors are harmonious, and much fine work is possible with them.

Yellow ochre is essential in any form of picture-making. It is quite permanent with the advantage of not dominating any other color with which it may be mixed. It is a yellow that is quite safe in any highlights, whereas lemon yellow and chrome are often too pungent or too powerful for the purpose of a painting.

Burnt sienna is a permanent color, and should be used with some care because of its strength and carrying power. A canvas on which too much wet burnt sienna has been used is very difficult to manipulate, as it stains any other colors that may be necessary to work into the wet ground. Used with discretion, it is an excellent servant, but makes a poor master.

Raw umber is an excellent drier, and useful for monotone paintings. It is often used to get the preliminary groundwork or to assist the general drawing and tone.

Venetian red and light red are two colors which are very strong and have much carrying capacity. Like burnt sienna, their strength penetrates somewhat at the expense of other tints, so that artists should be exceedingly careful to use the smallest possible portion when trying to get some experimental color, and to add any further red with extreme care. Light red is a little more yellow in color than Venetian red, but at the first glance there appears to be very little to choose between the two.

Terra verte is a peculiar color. It seems to be somewhat sensitive to being mixed with other tints. It is poor in body, but dries well. It has the merit of great permanency, and is used quite a lot for modifying warm flesh tints in figure painting, also for painting the subdued tones of trees as seen in landscape pictures.

The other earth colors are red ochre, rew sienna, and burnt umber. Red ochre is the hue of its name. Raw sienna is a deep yellow-brown. Burnt umber is a rich, deep brown. All are worth trying.

MEDIUMS AND VARNISHES

Mineral spirit can be obtained ready for artist's use. If pure, it evaporates and leaves no trace of its previous existence. Used as a medium, mineral spirit serves its purpose and then disappears. It should be perfectly volatile, otherwise disastrous results will follow, since there are certain greasy qualities in petroleum which never dry, and consequently produce most unhappy results. The best test is to soak it in blotting paper, after which it should leave no smell or greasy stain. This is often used by painters instead of turpentine.

Turpentine, like mineral spirit, is a volatile oil and, if pure, entirely evaporates. To test its purity, the same method can be adopted as suggested for mineral spirit: place a little of it on blotting paper, and wait until it evaporates. Afterwards, there should be no indication left on the blotting paper of any oily stain. It is most important that turpentine and mineral spirit should be kept in tightly closed bottles, so as to keep them from turning to resin through contact with air. Care should also be taken that only fresh and properly rectified turpentine is obtained from the art supply store. Its chief use is for thinning the paint, then evaporating entirely, leaving the oil and pigment behind. It helps quite a lot as a drier.

Linseed oil, poppy oil, and nut oil. These three oils are extracted from vegetable substances. They dry without evaporating, and increase in weight during the first transition stage of a liquid to a more solid matter, and then afterwards decrease in volume. The increase in weight is due to the amount of oxygen absorbed.

Linseed oil is generally used by painters, but it is safer to use it sparingly when mixed with the color pigments, as it turns acid more easily than the other two oils. Linseed oil is usually sold after being bleached by exposure to the sun. A picture that has become too deep in tone through the darkening qualities of linseed oil can be restored to a certain extent by exposing the painting to the sun, which bleaches the oil again and generally restores the picture to its former condition.

Copal varnish is a varnish that is mistakenly used by many artists as a medium for oil painting. Picture copal varnish should never be mixed with oil pigments. Its use is for the final varnishing of a picture.

Copal medium has found considerable favor with certain painters. It contains copal varnish, linseed oil, and turpentine. The medium should be used sparingly when mixed with oil pigment from the tube; a little goes a long way, since the tube colors are already ground with plenty of oily substances.

Mastic varnish and damar varnish are very clear, but perishable. After the evaporation of the liquid which dissolves the resin, the varnish leaves a hard, dry, and brittle skin.

This varnish is generally used for the final varnishing of a picture. It contains no trace of oil, and the resin is so brittle it can easily be taken off and another coat laid on. If pictures are not varnished, it is advisable to put them under glass, so that dirt or soot cannot damage the oil pigment.

Mastic and damar varnishes are better than oil varnish, because they help to protect the pigment below from moisture, unwholesome gases, and oxygen.

Some pictures about to be varnished have to be washed to remove particles of dust that have become entangled in the texture of the paint. This is all right if pure water is used, and the picture is made thoroughly dry and warm before applying the varnish. But in large cities, a greasy and unpleasant form of dust collects, which apparently cannot be removed without adding soap to the water. This is very serious, as the soapy water slips into crevices of the oil pigment, whether it has a rough or a smooth surface. Soap should be discarded since it is practically undriable, and invariably contracts moisture. Pictures varnished under these conditions will display a most unpleasant bloom or whitish fog. The best alternative to water is mineral spirit or turpentine; but skill, combined with a delicate touch, is necessary so as not to over-clean the painting, thus losing the vital paint touches of the artist. No oil picture should be varnished until at least six months after completion.

CONCLUDING REMARKS

The author feels that enough ground has been covered in this book (backed by practical color demonstrations) to convey a wide range of information to the potential artist.

The importance of acquiring some scientific knowledge of the nature and permanency of oil colors, oil media, canvases, etc., cannot be overestimated. The greater the artist, the heavier the responsibility becomes—not only to future generations, but also to the purchaser of fine pictures.

It appears to be a tragic paradox that some of the best artists in recent times have been the chief offenders in oil painting, without showing even an elementary knowledge as to the nature of the materials they used for picture-making. In some instances the results have been disastrous, whereas some lesser-known artists have adopted a successful formula in oil painting with good results.

SUGGESTED READING

Carlson's Guide to Landscape Painting, by John S. Carlson, Sterling, New York

Formulas for Painters, by Robert Massey, Watson-Guptill, New York

Landscape Painting Step-by-Step, by Leonard Richmond, Watson-Guptill, New York

Oil Painting for Beginners, by Frederic Taubes, Watson-Guptill, New York

Oil Painting: Methods and Demonstrations, by Henry Gasser, Reinhold, New York

Oil Painting Step-by-Step, by Arthur L. Guptill, Watson-Guptill, New York

Painting Cityscapes, by Ralph Fabri, Watson-Guptill, New York

Painting Landscapes, by Harry R. Ballinger, Watson-Guptill, New York

Painting Outdoors, by Ralph Fabri, Watson-Guptill, New York

Seascape Painting Step-by-Step, by Borlase Smart, Watson-Guptill, New York

Starting to Paint in Oils, by John Raynes, Watson-Guptill, New York

Technique of Portrait Painting, by Frederic Taubes, Watson-Guptill, New York

Technique of Still Life Painting, by Frederic Taubes, Watson-Guptill, New York

Edited by Margit Malmstrom
Designed by James Craig and Robert Fillie
Composed in eleven point Baskerville by Harry Sweetman Typesetting Corp.
Black and white printing by Halliday Lithograph Corp.
Color section offset by Artprint Co.
Bound by Halliday Lithograph Corp.

144